PROGRAMS OF PROMISE Art in the Schools

PROGRAMS OF PROMISE Art in the Schools

edited by AL HURWITZ

Coordinator of Arts,
Newton Public Schools,
Newton, Massachusetts

HARCOURT BRACE JOVANOVICH, INC. New York/Chicago/San Francisco/Atlanta

ISBN: 0-15-572150-X
Library of Congress Catalog Card Number: 72-190478
Printed in the United States of America

ACKNOWLEDGMENTS

Benefic Press for permission to use materials from *Art—
Meaning, Method, and Media Series* by Dr. Guy Hubbard and
Dr. Mary Rouse. © 1972 by Benefic Press.
Ronald H. Silverman for permission to use materials from
All About Art. © 1967 by Ronald H. Silverman.
Figure 2-4, 2-5: Courtesy of the Indiana University Art Museum
Figure 6-5: The Museum of Modern Art

To Helen, Tamara, Mark, and Michael,
 for obvious reasons

PREFACE

Today's art teacher finds himself at a philosophical crossroads. New theories and practices have opened up numerous possible routes toward different educational goals. This book is designed to provide an opportunity to explore the various directions in which art education is heading and to relate the changes that are taking place in this field to current movements and issues in education as a whole. It is intended not only for students preparing for careers in art education, whose opportunities to observe programs in action are generally limited to a few situations in the immediate vicinity, but also for experienced art teachers, supervisors, directors, and consultants, who may find in it new perspectives on the full potential of art in the education of children.

This book may also be viewed as a series of case histories written by the people most intimately associated with the programs. It thus embodies factual and interpretive reporting, not only describing each program but giving the rationale for its conception. Since the book deals with existing school situations, certain questions will come up immediately in class discussions. How appropriate is a particular program for one's community? Where does the training of the future teacher connect with the nature of the programs described and, if there is no connection, why is this so? Is it possible to subscribe to every idea that has been included? If not, upon what basis does one reject one solution in favor of another? There will obviously be many other questions that come to mind, and in seeking their answers the student may need to extend his research considerably.

I cannot close without mentioning my good fortune in being personally acquainted with all the contributors. To have observed most of them in action as persevering, devoted professionals has been the most gratifying experience of my career. I would also like to thank Professors Jerome Hausman of New York University and J. Theodore Anderson of Miami University for the great personal care they took in reviewing the manuscript. They brought a fresh eye and supportive attitude to the project and were of inestimable help.

A.H.

CONTENTS

Introduction 1

STRUCTURAL APPROACHES: TOWARD
ACCOUNTABILITY IN ART 3

Elliot W. Eisner — *Stanford's Kettering Project: A Radical Alternative in Art Education* 5

Guy Hubbard and Mary J. Rouse — *Art—Meaning, Method, and Media: A Structured Art Program for Elementary Classrooms* 15

Stanley Madeja — *A Systems Approach to Teaching the Arts* 33

Ronald H. Silverman — *Art Education for Disadvantaged Seventh-Graders: An Experimental Approach* 45

EXPANDING THE BOUNDARIES OF ART:
ART AND GENERAL LEARNING 59

Margaret Bingham — *Learning Dimensions: A Change Model for the Elementary School* 61

Don L. Brigham — *Visual Art in Interdisciplinary Learning* 75

REDEFINING THE NATURE OF ART: ART FOR
SELF-AWARENESS 87

Lowry Burgess — *The Hidden Landscape: Art for the Open School* 91

Rita DeLisi — *An Experiment in Visual Education* 103

Don Seiden — *The Metro Experience* 117

REDEFINING THE NATURE OF ART: ART FOR
SOCIAL PLANNING 127

Jan Wampler — *The Warehouse Cooperative School* 129

REDEFINING THE MEDIA OF ART 143

Lloyd Schultz — *Light Media: A Course in Expression and Communication* 145

BIOGRAPHICAL NOTES 161

INTRODUCTION

This collection of program descriptions presents the work of art teachers who vary widely in their approaches. Here are teachers who are trying to redefine for themselves the very meaning of art, teachers who accept conventional views of art but who are developing new frameworks of instruction, and teachers who feel that art processes such as perception, organization, and structure should be used for their potential in general learning; still others, with their vision directed beyond the classroom, are concerned with art behavior as a means to social ends.

The word "program" is used to mean a longer rather than a shorter project. I have chosen to include only programs that were designed for a semester's work or a full year, on the assumption that we can learn most from extended efforts that represent the kinds of long-term planning that new teachers must inevitably face.

My first intention was to include only contributions dealing with public schools. This idea worked very well until I met Rita DeLisi and Jan Wampler. It then became evident that public school teachers do not have a monopoly on constructive ideas. It is always risky to play the prophet, but I feel quite safe in saying that in the next decade the warehouse-storefront learning environ-

ments, like the other nonconventional ideas presented in this collection, will be very much a part of education. It will not really matter whether the good ideas come from the public or the private domain. Nor does it not bother me that most of the ideas presented here happen to be operating in the public—rather than private schools, because, for better or for worse, that is where most of the action is.

In reading these reports, the reader may be struck by certain disparities of style. Some of the essays follow a logically instructed format while others reflect the more intuitive base of their ideas. What finally emerges from the collecting is a mix of personality that should distinguish this book from similar efforts. The free-wheelers and the mystics are here along with the logicians. This only demonstrates that good ideas in education can come from many sources. Indeed, it may be that no one is more surprised at the company they are keeping than the contributors themselves. It is hoped that such sharing of the broad rubric of art education will be as invigorating to them as to the readers who stand on more neutral territory.

Some of the contributors have already achieved national recognition; others, either through reticence or modesty, have gained little attention outside their schools. All their efforts, regardless of ends or means, would seem to fit into what is commonly known as the curriculum, which may be defined as that broad enterprise that exists primarily in the lives of children at school and that is expected to bring about productive change. Though much

of education is an act of faith, it is assumed that such change is consciously planned for and that no planning is ever made without some ends in mind.

No personal stand has been taken on the curricula described, and no hierarchy of efficiency or worth of the programs was set. Obviously I have my own preferences; not all the programs excite me equally as to either promise or fulfillment. In selecting these reports, I felt that if a new program was successful in terms of its own stated objective; that students and teacher liked what was happening to them, such a program merited recognition. After all, none of the following programs has to be proved; each is a *fait accompli*—a going operation successful in the eyes of the students as well as the school setting.

This collection purports to be exactly as titled: programs of promise. These art programs are worth studying as examples of working solutions to questions that relate to the content, methodology, and goals of art. The collection does not claim to be comprehensive. How could it be in the face of the magnitude of the problem and the modest dimensions of this book? It does claim some degree of catholicity in its bringing together of curricular models of educational significance. *Programs of Promise* invites a critical task to be shared by the writer, who can only describe what is happening, and the reader, who must continue the dialogue by analyzing, interpreting, and finally, in the light of his own needs, judging. In this respect, at least, an art program can be approached as any other work of art.

Al Hurwitz, Editor

STRUCTURAL APPROACHES: TOWARD ACCOUNTABILITY IN ART

Reexamining the nature of art education is forcing some art teachers to respond to practice outside art education proper, where changes in the modes of instructon relate to the structure of the school itself. Men such as Jerome Bruner and Jerrold Zacharias, though not concerned directly with the arts, have nevertheless been instrumental in the move toward designing curricula out of the very fabric of a discipline by selecting its generating principles and then deciding upon appropriate levels of development within that discipline. Art educators such as Manuel Barkan have sought to apply such theories of learning to the teaching of art. Barkan's classification of art content into manageable units, components, organizing centers, and so on has come to be related to the current issue of accountability in education. Eisner, Hubbard, and Rouse, thinking along such lines, feel that they have faced up to the unfortunate fact that most elementary art in this country is not taught by art teachers. They reason that the best way to serve the classroom teacher is to avoid generalities and to describe sequentially an art program's specific objectives, stating concretely what changes are expected of the student.

Accountability, in essence, asks the agencies of the schools—be they teachers or principals—to be responsible for those learning behaviors that are felt

to be the desirable result of a stated goal of instruction. This certainly does not mean that priorities are set up on the forms in which changes are to occur; it does require the teacher to state in identifiable terms the behavior that could indicate the achievement of a particular end, whether that be the ability to center a pot, to discriminate between colors, or to weld two pieces of metal. Although all art teachers think in terms of stated behavior goals to a degree, few of them plan an entire year's work in such precise terms. Elliot Eisner's careful structuring of art learnings, Guy Hubbard and Mary Rouse's behavior-goals approach, and Stanley Madeja's emphasis on a systems method, all reflect a move toward greater precision in learning specifications. It is significant that all four have responded to the uncertain future of art teachers as agents of the art program and have designed teaching approaches for the elementary classroom teacher's capability. None of the contributors assumes that anything of lasting worth is going to happen spontaneously, and each places great value on the role of the teacher in judging how such basic art elements as color, design, and line may determine the production and critical judgment of art.

Ronald Silverman accepts the values commonly associated with art's meaning for the individual and does not quarrel with its conventionally accepted forms or contexts. But he is very concerned with the most effective ways of teaching art to ethnic cultures—in the case of this report, the Mexican Americans. In our zeal for assimilation, we have been guilty of ignoring the special needs of more than seven million Spanish-speaking Americans. While Silverman does not see the children of such minorities as requiring a special kind of art, he is convinced that they can best be served through a particular method of instruction. Art education textbooks have too often concentrated on similarities rather than differences among children. June King McFee was one of the first to direct attention to class rather than individual differences.[1] It is this distinction that very much concerns Silverman. Note also Silverman's use of a team of specialist-consultants to establish not only art content but information on the nature of children in this particular experiment. Silverman's use of a text is also unique, considering his student population.

It would appear from a study of the contributors to this book that the better known the art educator, the greater the likelihood of his being associated with structured approaches to art education. One might also infer that foundations and government support is more readily available for programs which are more specifically goal oriented. Such support is obviously necessary when programming is based upon lengthy preparation, trial and error—or as in Silverman's case, a format of empirical research.

[1] June King McFee, *Preparation For Art*, (Belmont, Calif.: Wadsworth, 1961).

STANFORD'S KETTERING PROJECT: A RADICAL ALTERNATIVE IN ART EDUCATION

Elliot W. Eisner

Can the quality of art education at the elementary school level be improved? Can elementary school teachers who are untrained in art be helped to teach art more effectively to elementary school children? Can art be moved from its peripheral position in the elementary school curriculum to one that is closer to its core? It was these questions that provided the animating spirit to Stanford University's Kettering Project.[1] What was the project up to? What were its assumptions and its goals?

In 1967, after about a decade of doing various types of research studies in art education, I decided to try to improve art education practices more directly by developing a curriculum that might be used effectively at the elementary school level. Other curriculum projects in American education had been developed in the natural and social sciences and in mathematics and I believed that something useful might be done in art education. The research studies that I had conducted on students' information about art and their attitudes toward it had convinced me of several things. First, high school students as well as students in college, even those who had studied art in high school, knew little about art. Second, their attitudes toward art, though moderately positive, had not changed very much as a result of studying art.[2] Other studies in art education as well as in general education and psychology provided data that indicated that the perception and production of art is not an automatic consequence of maturation.[3] Artistic activity, whether engaged in as a perceiver or a producer, is a complex affair and might be influenced by teaching.

These experiences, emanating from my own research and that of others, in addition to what I believed was in-

[1] For reports of the project see Elliot W. Eisner, "Curriculum Making for the Wee Folk: Stanford University's Kettering Project," *Studies in Art Education*, 9, No. 3 (Spring 1968), 45–56, and "Stanford's Kettering Project: An Appraisal of Two Years' Work," *Art Education*, 23, No. 8 (November 1970), 4–7, and Elliot W. Eisner, *et al.*, *Teaching Art to the Young: A Curriculum Development Project in Art Education*, School of Education, Stanford University, November 1969.

[2] Elliot W. Eisner, "The Development of Information and Attitudes Toward Art at the Secondary and College Levels," *Studies in Art Education*, 8 (1966), 43–58, Fall, No. 1.

[3] See, for example, Brent Wilson, "An Experimental Study Designed to Alter Fifth and Sixth Grade Students' Perception of Paintings," *Studies in Art Education*, 8, No. 1 (Autumn 1966), 33–42, and R. H. Salome, "The Effects of Training Upon the Two Dimensional Drawings of Children," *Studies in Art Education*, 7, No. 1 (Autumn 1965), 18–33.

adequate in the quality of art education at the elementary school level, motivated me to prepare a proposal to the Charles F. Kettering Foundation for the support of a curriculum-development project in art at the elementary school level. The Foundation funded the project in July 1967 and, during the two years that followed, a group of graduate students, elementary school teachers, and I embarked upon the task of giving reality to the visions that I had outlined in my proposal to the Foundation.

The work of the staff of the Kettering Project, as it was called at Stanford University, rested upon the following assumptions. First, it was assumed that the most important contribution that can be made by the visual arts to the education of the child is that which is indigenous to art. This means that while we recognized the fact that art activities can be used to achieve a wide variety of purposes—mental health, vocational training, the development of general creative abilities, concrete examples of ideas and artifacts for social studies—we considered the qualities that *only* the visual arts can provide to be its most prized contributions to the education of children.

Second, we believed that artistic action is the product of a complex form of learning and is not an automatic consequence of maturation. Children do, of course, produce drawings and paintings that have a great many similar characteristics at particular ages in their development. We do not take this to mean that the most effective road to artistic development allows this growth to make its own way without the benefit of sensitive instruction. We do not conclude from the fact that children's drawings have many similar characteristics that these characteristics are necessarily indicative of the highest levels of artistic development. On the contrary. These are levels that are achieved without the benefit of sensitive teaching. They are, so to speak, uncultivated levels of performance. The program we tried to develop had as its aim the expansion and increase of competence at each so-called stage.

Third, we believed that the curriculum offered to children in the public school should extend well beyond the traditional range of art activities. The visual-arts curriculum at both the elementary and the secondary levels is highly saturated with activities that involve youngsters in the making of art forms. This traditional orientation to the art curriculum has been by far the most predominant one in American schools. While we value such activities and while we believe that they ought to have a prominent place in school programs, we do not believe that they should have an exclusive place. Thus, the curriculum that was conceptualized and developed in the project attends not only to the productive domain—the making of art forms having esthetic and expressive quality—but to the critical and historical domains as well. These will be described in some detail later. Briefly stated, the critical domain aims at the development of the child's ability to perceive the world with respect to esthetic qualities. It develops a critical and appreciative eye. The historical domain attempts to help children understand the fact that art is part and parcel of human culture and that it affects and is affected by culture.

Fourth, we assumed that to teach art well requires not only a curriculum that is well thought out with respect to aims, objectives, and content but one that also supplies instructional support media useful for illuminating the visual qualities and ideas that makers of the curriculum hope to help children perceive and understand. To this end, the project attempted to develop a wide range of instructional resources in the form of reproductions, slides, specially prepared transparent overlays, and individually prepared drawings and paintings that both teachers and students could use in their work in art.

Fifth, we assumed that while not all, perhaps not even the most important, aspects of artistic learning can be evaluated, other aspects can be and that both informal and formal evaluation might prove useful for enabling both students and teachers to understand the progress they

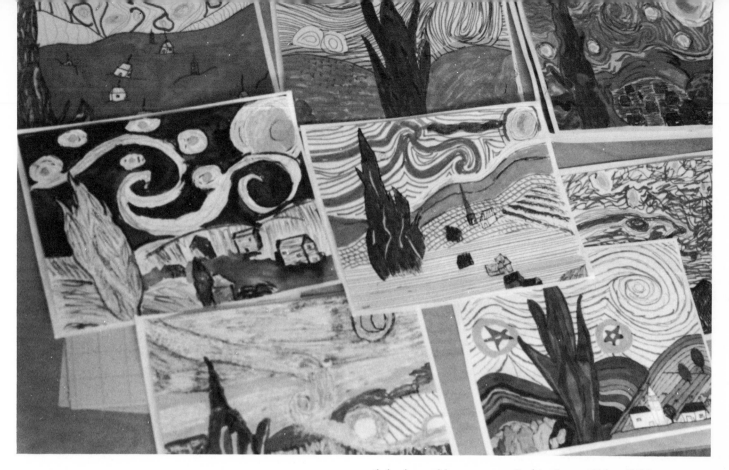

1-1. Improvising on van Gogh's *Starry Night*. Children utilize what they have learned in experimenting with color and line to develop improvisations on a painting. Such an activity, often frowned upon in the field of art education, is one example of the iconoclastic nature of the Kettering Project.

make in the pursuit of artistic goals. These evaluation procedures were suggested at the end of each instructional lesson or unit in the syllabi. We hoped to secure evidence from them on the effects of our work.

Finally, we assumed—and this is the most important assumption we made—that elementary school teachers untrained in art, working in self-contained classrooms, would increase their effectiveness as teachers of art if they could use a sequentially ordered curriculum accompanied by specially designed instructional support media. This assumption was of course a crucial one, since without it we would not have proceeded in the first place. We hoped to demonstrate that significant improvement in the teaching of art is possible, that the traditional conception of the

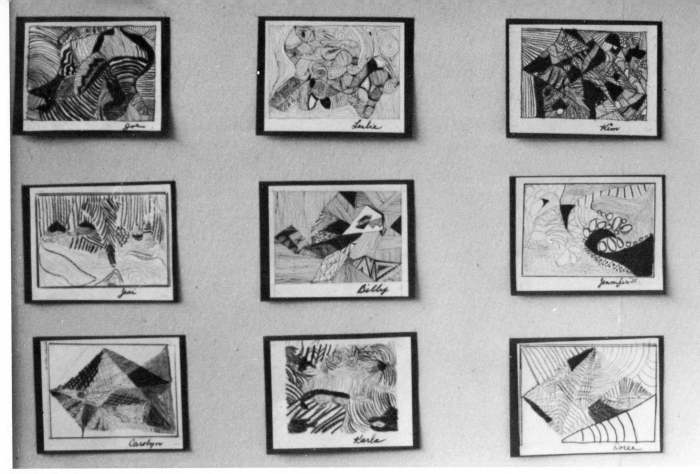

1–2. Examples of line exercises. These drawings, done with colored felt-tipped pens, are designed to develop graphic and compositional skills in the use of line and are instrumental in expressive art activities.

child and his development in art is not a necessary one, and that the unique contributions that the visual arts are capable of making can be realized by people other than specialists. The Kettering Project sought no less than a radical overhaul of concepts, aims, and methods of elementary school art education.

The radical nature of the project can be appreciated only if one understands the character of the practices and assumptions that typically underlie programs of art education in American public schools. One of the most pervasive assumptions is that children develop their potentiality in art if only they have a warm, supportive teacher and materials with which to work. The notion that a teacher can teach something in art and that children can learn from the teacher has not been salient. Indeed, two of the most influential textbooks in the field of art education, *Creative and Mental Growth* by Viktor Lowenfeld and *Education Through Art* by Herbert Read,

have no entries in their indexes under the concept "teaching." Art, it has been assumed, is not taught; it is caught. The teacher is to be, in Herbert Read's terms, "a psychic midwife."[4] The Kettering Project based its practices on the belief that sensitive teaching does not hamper children and that there are a content and an array of skills than can be learned in art.

In addition to this notion, contemporary practices in art education have tended to devote their attention exclusively or mainly to the productive aspects of art—that is, to asking children to make objects. The Kettering Project dealt not only with the productive aspects but with the critical aspects of art as well. The critical aspects of the art curriculum were aimed at helping children develop their ability to see visual form and to experience it emotionally, while the historical aspects of the curriculum were aimed at enabling students to understand that art is always produced within a culture, that it reflects that culture, and that at times it affects the culture in which it was created.

Still a third idea that has permeated art education practices in American schools is the belief that the major goal ought to be that of fostering children's creativity. Art education is supposed to deal with the development of creativity in the young. The staff of the Kettering Project recognized that art educators have no monopoly on the development of creativity. Indeed, when they are well taught, science, mathematics, social studies, and reading can also develop the creative potentialities of the young. But what art education can do that other fields cannot is develop the child's ability to see the visual world esthetically; it can develop his visual imagination and the skills necessary for expressing his imaginative insights in some public, material form. This, it seemed to us, was

the truly unique aspect of art education. This is where its special province lies.

Thus, the educability of vision, the expansion of the curriculum to include the critical and historical realms, the belief in the need for teaching and learning in art, these were some of the leading ideas in Stanford University's Kettering Project. What was its format? What types of materials did it develop and employ? How was it implemented and tested? It is to the answers to these questions that I shall now turn.

From the standpoint of funding, the project extended over a two-year period. The first year was devoted to problems of conceptualizing the categories of the curriculum, designing the learning activities, developing instructional materials, field-testing what had been developed, and making appropriate revisions. The second year was de-

1–3. Experimenting with color intensity and value. This fourth-grade girl is engaged in the exploration of color through the use of tempera paint.

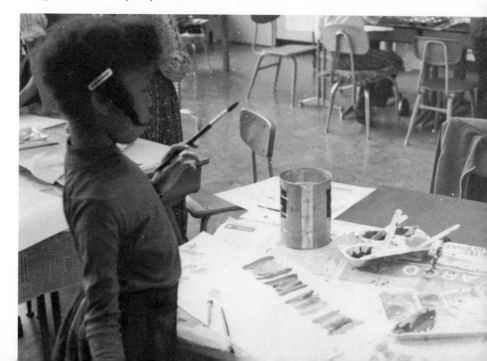

[4] Herbert Read, *Education Through Art*, 3rd rev. ed. (New York: Pantheon Books, 1956), p. 209.

voted to expanding the number of schools in which the materials were used, increasing sevenfold the number of teachers using the curriculum, and developing a formal evaluation procedure to assess the utility and effectiveness of what had been prepared.

During the first year of the project, approximately twelve graduate students and elementary school teachers participated in the formulation and testing of the curriculum. Whenever a group is formed to prepare written and visual resources that teachers might use in the classroom, terms and categories must be formulated so that there is some commonality to the efforts that will be made. The categories that constitute the curriculum are called the curriculum structure. These categories are the

skeleton around which materials, information, teaching hints, and learning activities are built. Stanford's Kettering Project contained the following curriculum structure:

Domain
↓
Concept or mode
↓
Principle or medium
↓
Objectives
1. Instructional
2. Expressive
↓
Rationale
↓
Motivating activity
↓
Learning activities 1, 2, and 3
↓
Evaluation procedure
↓
Materials

Each of these categories will be described briefly.

The productive, critical, and historical domains constituted the areas within which curricula were built: making visual form, learning to see visual form, and understanding the cultural aspects of visual form in the history of art. Within each domain we identified a concept or mode. In the critical domain the concepts were

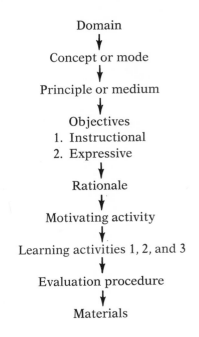

1–4. Working from a painting by van Gogh. The materials and the cube drawing provide some indication of the kinds of drawing tasks that children practice in the project.

color, composition, and line. Each of these had an accompanying set of principles such as "Color can make a surface vibrate" or "Composition can be symmetrical or asymmetrical" or "Line can convey or elicit feeling." Principles are simply empirical generalizations about visual form. About ten principles were formulated for each of the three concepts. In the productive domain we identified a mode of work rather than a concept. A mode of work in art is, for example, painting or drawing or sculpture. Accompanying each mode is a material. Thus, the mode called painting can be employed with materials such as water colors, tempera, ink, acrylic, oil color. In the historical domain no concepts were formulated but principles, such as "Art changes through time," were.

Following each principle or material the curriculum guide provided one of two types of objective, instructional and expressive. Instructional objectives were aimed at helping children acquire particular skills useful for artistic production, while expressive objectives were aimed at encouraging children to use those skills imaginatively.

The objectives were followed by a rationale which, when stated in a paragraph or two, tried to explain to the teacher why the principle or objective is considered important. The last thing we wanted was teachers using materials with no understanding of why they were using them.

Following the rationale was a suggested motivating activity, which was simply a suggestion to the teacher as to what might be done to help students get ready for the activity. Following this were two or three suggested learning activities from which the teacher might choose one that was thought to be best suited to the class. Indeed, if the teacher could invent a learning activity for achieving the objective, she was encouraged to do so.

Finally, a suggested evaluation procedure was provided in about half of the seventy lessons that constituted the curriculum guide that the project staff had developed.

There are two characteristics to the project that are considered extremely important. The first consists of the concepts of sequence and continuity among the lessons within each unit. Most art programs in elementary schools provide very little in the way of sequence and continuity of the art activities that students engage in. Yet artistic learning is complex, and superficial, one-shot excursions are not likely to develop the skills or sensibilities that art and its appreciation and understanding require. Thus, the lessons in the Kettering Project build upon one another. A unit, say on painting or on color, has from seven to ten lessons and teachers are urged to move through these lessons sequentially. It is only when a child can manage the material with which he is working that he has the freedom to use it as a medium for artistic expression. What we have attempted to develop, therefore, is a series of ten lessons within each of seven units in three domains that will facilitate significant modes of artistic learning among children in elementary school.

The second important feature of the project is the development and provision of approximately seven hundred pieces of instructional support media especially prepared and coded to accompany the curriculum guides. It is ironic that although science, mathematics, and social studies have made great use of visual media for teaching purposes, art educators have seldom looked beyond "art supplies" as useful vehicles in teaching and learning. What we have done is design or acquire slides, reproductions, textile boards, original drawings, transparencies, and a host of other devices to accompany the particular units and lessons in the guide. Thus the classroom teacher has at immediate disposal a wide variety of instructional resources for teaching or demonstrating some visual idea. Students, too, can make use of these devices, which are contained in a large "Kettering Box" in the classrooms of the teachers who participated in the project.

How does a teacher use the Kettering materials? In what ways might they facilitate teaching? First, a teacher looks through the Kettering syllabus to select the unit most appropriate for the class. Once having located this unit, the teacher reviews the lessons within it to select the lesson that is suitable for the whole class or for groups or individual children within it. The lesson to be selected might be the first in the unit or, if the children are more advanced in their ability in that particular unit, it might be the fourth or fifth lesson or even the seventh or eighth. After selecting the lesson, the teacher then selects from the Kettering Box the instructional materials to be used with the lesson. For example, if the unit is on line and the lesson deals with the problem of helping children recognize that different kinds of line convey different moods or expressive qualities, the teacher selects from the

Kettering Box certain display sheets that the children can view; the teacher and students then discuss the differences in linear quality that each sheet displays. These visual display sheets have been especially developed to contrast the expressive qualities of line. Thus, one shows a tree in which line is used gracefully, almost daintily, while another shows a tree in which the line is bold and strong. The children look at these displays and discuss them, noting differences and similarities. The teacher tries to help them appreciate the fact that the differences in their expressive qualities are due to the way in which line is used in each.

Following this lesson the teacher moves the class on to the next. This lesson builds upon the preceding. The children might be given felt-tipped pens and be encouraged to explore the ways in which line can be used to

1–5. A look at the classroom. The Kettering Box, which contains materials utilized in the project, can be seen beyond the children's desks. On the walls are examples of some of the work they have produced.

1–6. Experimenting with color. The children are working on color experiments designed to acquaint them with the characteristics of tempera paint. They will then apply what they have learned to more expressive curriculum activities.

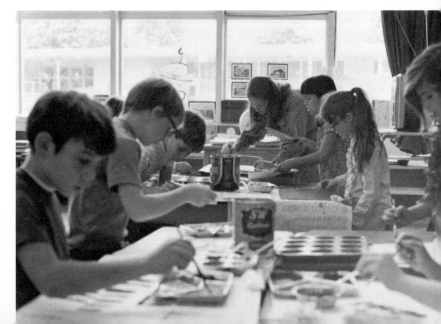

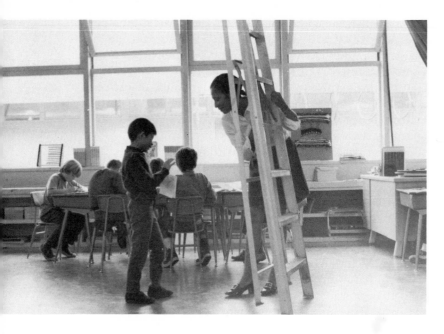

1–7. Time for consultation. A teacher working on the display of children's work takes time out to talk with a student about his work. Students are encouraged to develop self-direction and to work in large measure independently.

1–8. Using light on dark. Here children are experimenting with the relationship of light colors on dark paper, a particular problem in a sequence on color.

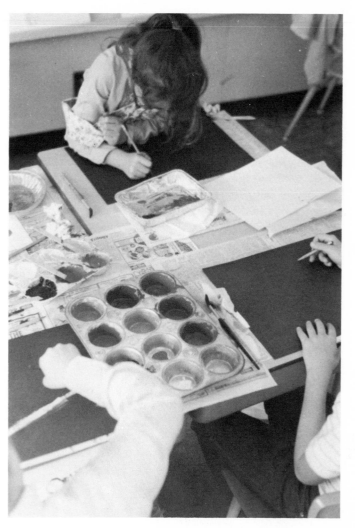

create various patterns and textures. The purpose of this lesson is to help acquaint the children with what a felt-tipped pen will do. That is, the lesson is exploratory. After such exploration the teacher again uses the visual resources of the Kettering Box and shows the children how contemporary artists have used line in their drawings and paintings. The children are then asked to pick out and describe lines in the classroom. Such a discussion might first focus on "obvious" lines, such as the chalk ledge of the chalkboard or the corner of the room, but the discussion could then be extended to the contour of solid shapes. The children might begin to see the linear aspects of the world in a way that had previously not been apparent to them.

Following this series of activities, the children could be given paper and felt-tipped pens and encouraged to do imaginary line drawings that express some emotional quality through the way in which line is used. Beyond this, they would use line in pictorial representations.

What we see in this sequence of lessons is a gradual widening and deepening of the child's appreciation of line in nature and as an expressive vehicle in the visual arts. The sequence is important inasmuch as it allows a child to practice and internalize what he has learned. The major goal of such a sequence is to develop a degree of mastery in both the critical and the productive domains. In this task the teacher utilizes the visual resources provided in the Kettering Box and the suggested learning activities.

In summary, we may say that Stanford University's Kettering Project represented a two-year effort to conceive, develop, implement, and evaluate a curriculum in the visual arts for elementary school children. The project was designed for use by elementary school teachers with little or no background in art or art education. The materials that were developed include a two-volume curriculum guide containing seventy lessons within seven units distributed among three domains of artistic learning; the productive, the critical, and the historical. Accompanying these volumes are about seven hundred instructional resources contained in large boxes and coded by number to the lessons in the guide.

These resources and the theoretical ideas that gave rise to them represent a radical departure from tradition in the teaching of art in the United States. At present the project and its leading ideas are being employed in schools in California, Hawaii, and other states as well as in Israel and other countries. Although no curriculum can guarantee success, and certainly the Kettering Project cannot, the evaluation and feedback received thus far suggest that the project is useful and that, as *one* approach to curriculum development, it can make a positive contribution to both students and teachers at the elementary levels of schooling.

Guy Hubbard
and Mary J. Rouse

ART—MEANING, METHOD, AND MEDIA: A STRUCTURED ART PROGRAM FOR ELEMENTARY CLASSROOMS

The tradition of art teaching in the elementary school can be divided into two general categories: nondirected self-expressive activity and highly directed instruction that focuses on the making of particular products. Neither one has been notably successful, since art is not taught in any consistent pattern in spite of the fact that more than a century has passed since it first appeared on the scene in American schools. The picture for elementary school art is, in fact, distinctly gloomy.

The statistics speak for themselves. Approximately 90 percent of elementary art is taught by classroom teachers of whom only 15–20 percent receive help from art specialists. Of the 10 percent of children who are lucky enough to have art instruction from professional art teachers, most are likely to meet their art teacher with a frequency of anywhere between twice a week and once a month. In many elementary schools, art flourishes in outstanding ways, but the predicament of the vast majority is a tragic commentary on the esthetic vitality of the nation.

The condition of art in the schools is clearly critical. But what can be done about it? In an attempt to answer this question, we considered how the problem might be attacked. Without doubt the best solution is to have a talented art teacher in every school. Even increasing the present number of elementary art teachers might turn the tide, if only by enlarging the possibilities of personal contact. And yet, as desirable as such a solution is, it would be hopelessly romantic to expect it to occur in the current educational climate and equally hopelessly unrealistic in view of the expanded training programs that would be required.

Similarly, the allocation of plentiful time during the school day and adequate funds for the purchase of materials will not happen. Educators in all subjects are scrambling for class time, and the financial strictures presently being experienced in all areas of education suggest that budgets are going to be even tighter in the future. Meanwhile, the public is expressing a growing demand that all teachers be held accountable for accomplishing acceptable and observable objectives. An art show at the end of the school year and a few token products at Halloween, Christmas, and Valentine's Day are not going to be enough to maintain art even at its present

2–1. Examples of children's art are included in the lessons to assist both children and teachers in reaching lesson objectives. An illustration from a Grade One lesson in creating three-dimensional forms by altering and assembling given items.

level, not to mention the creation of a more liberal point of view about the place of art in the schools. If these are dismal conclusions, they seem to be supported by the facts: they are realistic. Any resolution of the problem, therefore, must operate within these limitations or fail. The ideas and practices that have emerged from our studies and from our search for practical solutions are described in the body of this article.

We have attempted to devise a program suitable to the conditions commonly found in elementary schools. We tested it and are now making it available generally for teachers. All the art materials involved are inexpensive and of a kind already commonly found in schools. The time allotment of eighty minutes a week—or of two forty-minute lessons a week—is minimal and corresponds to somewhat less than state departments of education typically recommend for elementary art. We used an age-graded organization, despite the questionable nature of the practice, simply because the vast majority of schools are organized in this way. Since specialized advice is not generally available in self-contained classrooms, and since classroom teachers can be expected to have little or no art background, the program is as complete as possible. It consists of written information for the children, advisory notations for the teacher, and pictorial resources. While vagueness in objectives in art teaching may be allowed to exist in curricula used by specialists, no such liberty is possible where the teachers lack art experience. Thus, objectives were developed that could be clearly understood both by children and by classroom teachers. Further, and in recognition of the circumstances being faced, we adopted a clearly defined *sequence* of instruction in which learning pursued a *developmental* line. Given the conventional approaches to art teaching, this one may seem radical. Since the current problem has shown itself to be beyond the means of conventional philosophies and practices, however, the departure seemed justified, if it would work. What follows

2–2. An illustration from a Grade Two lesson about preparing and using paint, painting in an individual way, and thinking about what should happen in all the spaces in a picture.

is an elaboration of the statement above, a presentation of the program and its application in more detail.

The basic concept of the program is a matrix, or framework, composed of six types of objective. Each cate-gory of art learning includes all the objectives that can reasonably be expected from children working under the direction of a classroom teacher in the typically modest surroundings of an elementary school classroom. The

categories describe special kinds of art tasks a child can learn to do. Each one contains a clearly defined parcel or unit. Each has a descriptive title, as follows:

> *Learning to Perceive.* The abilities required for making esthetic decisions and performing creative artistic acts depend on the corresponding development of the senses of sight and touch.
> *Learning the Language of Art.* There are formal artistic elements and principles of art about which we read and talk and that we apply.
> *Learning about Artists and the Ways They Work.* The study of art involves knowing about different kinds of art and different kinds of artists. It also involves learning about the characteristics of creative people.
> *Criticizing and Judging Art.* Certain criteria and points of view need to be known and perceived in order to make esthetic decisions about works of art and objects in the visual environment.
> *Learning to Use Art Tools and Materials.* In order both to understand art and produce it, certain knowledge and skills in the effective use of tools and materials are needed.
> *Building Productive Artistic Abilities.* The study of art involves the acquisition of a store of artistic competences to correspond with verbal learning about art.

The objectives, or "learning tasks," are stated "behaviorally." This means that, by reading an objective, both the teacher and the child know what to look for. When evidence of the accomplished task can be found, then that part of the program is said to have been mastered. Here are examples of objectives selected from different grade levels:

You have made a paper weaving. (grade 2)

You have helped to set up a pleasing display of art work to make the classroom look better. (grade 4)

You have cut out a number of squares, circles, and triangles and used them to demonstrate dominance in a design. (grade 5)

Over one thousand of these tasks appear in the matrix under the six categories.

The condition that all proposed entries had to meet was that they could be achieved in a typical self-contained classroom. The decisions as to whether this condition could be met could not be made on the strength of what one or two people felt was appropriate, whatever their level of expertise. Consequently, two general procedures were followed to ensure as much as possible that the best choices were made, both whether to include an objective and where to place it in the program. The first procedure required that the attainment of an objective be consistent with the findings of research literature on children's development in drawing, perception, creative abilities, and esthetic judgment.

The second procedure occurred later and called for classroom testing to determine whether the objectives were in fact practical choices. At the first level of acceptance, we grouped objectives into clusters under their descriptive categories against the grade level that they seemed to fit best. The result was a matrix composed of columns of different types of art-learning objectives and rows that showed where objectives relating to particular grades in school might best be placed. The sum of art to be learned for a year consists of about one hundred and fifty new items, except for the first year, in which double that number appears, many of the items being common to much of what is usually learned during grade 1. This master set of specifications states only what a child will know and be able to do by the end of any given year and, cumulatively, his level at the time he graduates from elementary school. It does not make any commitment about how his minimal goal for art education is to be

2–3. An illustration from a Grade Two lesson introducing collage that includes such objectives as collecting interesting scrap items, assembling them into a Thanksgiving symbol, and using glue properly.

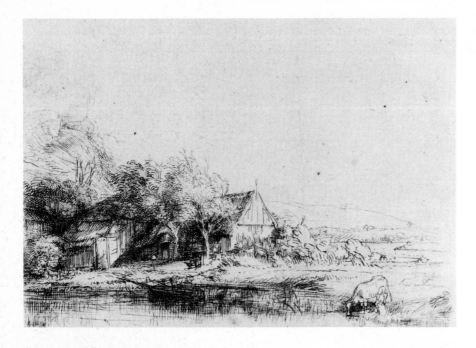

reached. Innumerable means could undoubtedly be used to achieve it.

The particular approach of the program grew out of what we know about the people who would use the program and the conditions under which they work. The result, again, is austere yet practical, and defensible in view of what we currently know about educating people. A year of art lessons is unwieldy, so we subdivided the lessons into smaller, more manageable blocks. The various festivals of the year were marked off for exploitation because they are a fact of school life. Thus, Halloween, Thanksgiving, Valentine's Day, and the rest become vehicles for clearly defined learning and expression in art, where the stimulus of the occasion might add impetus to learning. We also felt that the course content, as

2–4. Rembrandt van Rijn, *Landscape with Cow Drinking* (etching)

2–5. Lyonel Feininger, *Kleinstadt* (engraving)

2–6. A Grade Three lesson is directed toward the use of drawing as a way of remembering things. The lesson objectives also involve trying out different ways of drawing. The works by Rembrandt and Feininger illustrate not only two styles of drawing but, the different things artists see. Artists' works also present models of excellence for children.

planned, could move teachers and children away from the customary stereotypes that one associates with holiday art. These festivals are also typically related to some kind of vacation, so in addition they make natural breaks in the year. The undisputed importance of the familiar school subjects—language, literature, mathematics, social studies, and science—led to their being harnessed also. A review of numerous school textbooks in these subjects revealed many areas of potentially mutual benefit that in no way subordinate art. As a result, modifications were made to the original set of objectives. Examples include the following:

> You have drawn an example of art made by people who live in your neighborhood or community. (grade 3)

> You have drawn a fantasy design or picture with rulers, templates, and pencil compasses. (grade 4)

Clusters of objectives appeared as a result of this subdivision of the overall objectives for a given year. After some trial and error, we assigned about four objectives to each forty-minute lesson period. This seemed to be an optimum figure under most circumstances. As each year progresses the number of repeat objectives increases, so as to ensure that they are not only learned but remembered. This tends to increase the overall number of objectives for a given lesson. Throughout the period of this planning and early trial, a general screening called for the appearance of simpler objectives with the earlier lessons while the more difficult ones were reserved for later in the year. We should emphasize that at no time during this phase of planning did we concern ourselves with art lessons in the conventional sense; we dealt only with the deployment of objectives. Achieving desirable objectives, after all, is the only good reason for having an educational system.

During this stage in the program development, we had almost infinite flexibility in planning: the parts of the matrix could be moved around with great freedom. But, once again, if the major problem of elementary art was to be attacked, the special clientele to be served, the classroom teacher, had to have central importance. No curriculum design can remain fluid indefinitely, least of all this one. Art teachers may be able to develop their own permutations of objectives and may have the control

2–7. A fifth-grader completes the decoration of plaster holiday shapes.

necessary to avoid tedious duplications or important omissions, but classroom teachers certainly cannot be expected to do so.

The program now began to take shape as a sequence of lessons. But this was possible only because a systematic and well-defined set of objectives had been developed as a foundation. Sixty lessons extend over a typical school year of thirty-six weeks, with a few weeks to spare for the inevitable unexpected events that affect every school. Each lessons is of forty minutes' duration. Approximately four lessons make a sequence; experience made it clear that longer sequences tend to lead to a falling off of interest from both child and teacher. Since nothing can be taken for granted concerning what teachers and children know or how they may handle tasks, each lesson is presented in as complete a way as possible, even to the inclusion of details that some might think to be quite unnecessary. Art teachers might rebel over the degree of detail, but the classroom teachers with whom the program was used welcomed the kind of advice that was presented. Some examples are as follows:

Check with the principal for permission to have the class work in the halls. If he feels this might be disruptive, they will have to work within the classroom. (grade 1, textures)

Not all collected items need be used in the work. And they may be dismembered for more interesting parts. (grade 2, collage)

Only the nearest figures should be completely visible. Some children may be able to overlap and obscure buildings but not be ready to obscure people. (grade 3, overlapping)

While experience in field-testing made clear the need to include almost simpleminded detail, it is also clear that teachers disregard lesson material completely if they think it too lengthy. The art of designing the program

lay in deciding on an effective compromise and then trying it out in schools.

Every lesson has the same number of parts. Each divides itself naturally into two sections, one for the teacher and one for the child. Children and teachers grow to expect this division after a while, which gives stability

2–8. Illustrations often are more instructive than words. Lessons include diagrams such as this one on drawing around templates.

to the program and provides a base from which the more individual activities may emerge without threat. Each lesson includes both verbal and visual components. The verbal communication presents a narrative for the child that introduces what is to be learned. (See A and B in the lesson example.) The reading level corresponds to what is typically found among children for a given grade. The children also receive information about the materials needed for the lesson. (See D in the lesson example.) If any special kind of materials is required from home for the subsequent lesson, then this, too, is written in. The children also find a statement of the objectives for the lesson drawn from the matrix, so they can check their own successes (C in the lesson example). Neither the children nor the teacher is burdened with the full matrix at any point, however. Overprinted on a copy of the children's materials are instructions for the teacher about what she is to do (E in the lesson example) and at approximately what time she should make these efforts during the lesson. Additional helpful hints on how to teach the lesson or how to use special materials are also provided (F in the example). Classroom teachers usually asked for more rather than less of this kind of guidance during field-testing.

GRADE FIVE
LESSON PLAN, TEACHER EDITION
Lesson 29
(TIME: 44–46 MINUTES)

(Child's text)

Delivery You are to:

E ▷ 1. Have a student read the first paragraph aloud to class. (*2 min.*)

2. Have a student read directions aloud. (*3 min.*)

3. Distribute materials. (*5 min.*)

4. Have children bring plaster shapes back to desks. (*2 min.*)

5. Call attention to the visual aid which shows a child using pen to put decorations on a plaster shape. (*2 min.*)

6. Begin working. (Remind children to try out tools first on paper before using them on plaster shapes.) (*18–20 min.*)

A ▷ Decorating Plaster Holiday Shapes. Now is the time to put your decorative designs on the plaster shapes that you poured during the last lesson. Before you do, look again at the holiday shapes shown. Notice how colorful they are. Notice how lines and colors have been used to make each one different from the others. You can make yours just as interesting and unique.

B ▷ Get out the designs you planned on the first day of the project. Use small brushes and tempera paint or colored ballpoint pens or small felt-tipped pens to practice making the kinds of lines, textures, and shapes that you will need to make on the plaster shapes. Use paper for your practice. Work until you think you can use your tools easily and can make the designs you planned.

When you have practiced enough, bring your poured plaster shapes to your desk. (Be very careful, in order not to break any!)

Then begin to put a design on one of them. Be sure that you do not put much pressure on top of the plaster shape or it will crack. Handle it very lightly.

When you have completed one, go on to work with another, in the same manner.

When all your shapes are finished, inspect them carefully. Compare them again with the designs you made to be sure that you put all the lines, colors, and shapes on them. If you did not, now is the time to go back and do it.

7. When finished, hang up a few and have children analyze them for appropriateness of color, shape, and line, and uniqueness. (*7 min.*)

8. Clean up. (*5 min.*)

▷ ART LEARNING You have:

1. Put prepared designs on plaster shapes with pen or brushes.

2. With classmates, verbally compared finished plaster shapes for visual interest, uniqueness, and appropriateness of color, shape, and line.

▷ *Hints* Remind children several times to be extremely careful when handling plaster shapes. They will break very easily. If they wish to take them home later, they should probably be wrapped in tissue and carried in a flat box.

▷ ART MATERIALS plaster shapes made during last lesson; paper; colored ballpoint pens, felt pens, small brushes; tempera or colored inks; water containers; mixing trays; sponges; paper towels; smocks or aprons; buckets of water (if there is no sink); thumbtacks or tape; old newspapers.

Art cannot be learned without visual imagery. Thus, every lesson includes pictorial matter to assure that the teacher is given every opportunity to help the children reach the given objectives. The visual aids are both full color and in black and white, as needed. They fall into four categories: children's art corresponding to what is to be done in class, work by professional artists, sketches and diagrams that assist in learning specific skills and procedures, and photographs that supply miscellaneous visual information. The examples of children's art serve to give an idea of what the art for the lesson might look like. Reasonably average products were chosen to avoid frustration. The fear that children would copy what is in front of them has not been realized in practice to any marked degree, since it seems that children typically look on work by their peers more as objects to surpass than

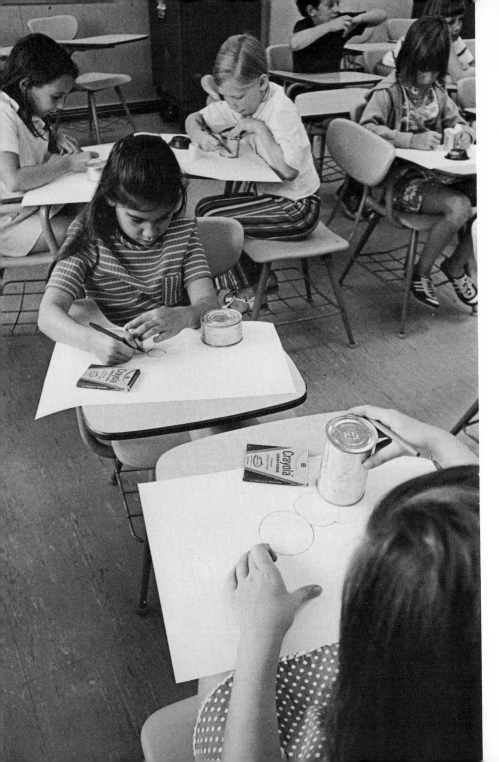

as something to imitate. The reproductions here give an idea of the children's work and the purposes for which they are used.

The work of artists plays an important part in the program. It presents selections of the best artistic expression. These works serve specific learning objectives, however, and do not imitate the outmoded tradition of "picture study." Some of the works shown here are also used elsewhere in the series to serve different learning objectives.

The third type of visual aid takes the form of instruction that cannot be handled as well in any other way. A number of skills are required in art for which verbal descriptions are inadequate. The children may not be able to receive personal demonstration of what they are to do, since classroom teachers are themselves unlikely to have the required skills, at least initially. Therefore, a sequence of illustrations offers a reasonable substitute for demonstration by an expert. Various other objectives can best be achieved by illustrations and diagrams.

Finally, there are illustrations of materials that the child needs to know. Very few people, even those trained in art, accurately remember the details of the world around them, even parts of it seen only a short while earlier. A picture can assist in recall for various learning objectives. Very often neither the children nor the teacher can be expected to have much experience with certain kinds of images; the picture in these instances introduces the information to both of them. At all times the pictures lead to the learning of one or more objectives in a lesson.

The program as a whole is self-explanatory—that is, no in-service or other preparation is essential before a teacher can put it to use in the classroom. In-service work

2-9. A class at work building designs from template drawings.

is desirable under the guidance of a competent specialist, but the effective use of the program does not require it. A fifteen-hundred-word introduction simply informs the teacher about the program organization and how it can best be used. In addition, while the information for the lessons is as complete as possible, teachers need to know what the year's work consists of. A table of contents lists the objectives in clusters of lesson sequences that show the relationships between lessons. Next comes a list of the materials required for the entire year. This list includes an estimate of the quantities required and also a reference to the lessons in which these materials will be used. Armed with this information, a teacher not only knows what to order but can check her supplies at any time relative to future needs for any item listed. In a very few of the lessons teachers have to ask children for supplements of materials from home. These items and the lesson references are listed with the summary of art supplies; they also appear (as mentioned above) in the lessons immediately preceding those in which they are needed. At the end of each annual sequence of lessons is a glossary of the terms used throughout. It is cumulative and helps to ensure that the terminology remains substantially the same from teacher to teacher across the six grades and even from school to school within a district.

The program has been field-tested with nine thousand children and 330 classroom teachers. City and suburban locations were chosen. Some of the schools had large black populations and others had predominantly white populations. The actual work in the schools occupied a critical part of the curriculum development, since theory had now to be translated into practice. Many modifications to the original material occurred during this period, most of it because teachers made suggestions about how lessons might function better. They requested that esti-

2–10. A finished template design, executed within the limits of a forty-minute lesson.

2–11. In a three-lesson sequence for Grade Five on environmental aesthetics, photos are used for discussion of what is visually pleasing and what is visually displeasing in the community. New Library, Indiana University.

mated time intervals within the forty-minute lessons be stated. They suggested the shortening of the children's text and the rearrangement of the format of the pages to make it easier to use. They also pointed out unsatisfactory lessons. The children themselves contributed to this process, because when they did not like a lesson they usually made no secret of it. This feedback led to the rewriting of most of the lessons. Objectives were redeployed to other parts of an annual sequence and even moved to other grade levels. Lessons were tested and retested.

The first response to the idea of the program by classroom teachers was enthusiastic, and yet they expressed some uncertainty when it actually came time to use the lessons. As classroom teachers they had never been expected to have expertise in art, and now they had to teach not an occasional class but a continuing program. This initial uncertainty, together with their all too com-

2–12. Street scene

2–13. The sequence on environmental aesthetics culminates in the production of a poster.

mon fear of art, tended to dissipate as they found the program to be comparatively easy to manage. With their fears removed, they rapidly became competent within the limits of their experience and the limits of the program itself. At first, teachers found the time allotments to be too short. With experience, this handicap disappeared. Classes tended to become smoother and more relaxed after only a short while. An indication of the growth in art among teachers when given a model to follow lies in the number of additional visual aids that numbers of them collected to supplement those that were provided. One of our worries had been that too few examples were possible in view of the expense of printed reproduction, artist's diagrams, and photographs, particularly those in color. The teachers' initiative opened the way to the very opposite outcome.

One difficulty persisted with the program, even after it had been in use for some time. Teachers were prone to

evaluating their own success and that of their students by the degree to which the products were visually appealing. They recognized intellectually that success was related only to the achievement of objectives (and not all of these led immediately to beautiful products) and yet they then responded emotionally to the visual appeal that the products had for them personally. At no point in the program, however, did the teachers' own preferences feature as objectives. Quite the contrary. The problem is deep-seated and difficult to resolve. The best that has been observed thus far is that professional responses gradually increase with the use of the program and that the amount of improvement is relative to the character of the teacher.

The prototype materials used in the field-testing were reproduced by various office-machine duplication methods. Each child and the teacher received at least one sheet of printed or illustrated paper for each lesson. Thousands of sheets of paper had not only to be printed but packaged and distributed to widely dispersed schools. This caused many problems, and revisions compounded the difficulties. Presenting children with suitable visual materials was handled satisfactorily with large prints and drawings in the early stages of testing, but as the numbers of materials and students increased the substitution of prints by filmstrips became necessary. The filmstrips were organized into sequences corresponding to the lessons. While this served well enough for supervised testing, it could not be compared with having printed reproductions immediately in front of the children to be viewed for indefinite periods. The program in its final form appears as a textbook series that combines all the visual and verbal information. The work of each of the six years fills a separate book and every child has his own copy, just as in the other disciplines. The teacher's copy includes instructions overprinted on the child's text together with the introduction and glossary. Given this comprehensive guide, all the teacher has to do is acquire the needed materials (kinds and amounts of which are clearly stated) and schedule the lessons.

The reader should be in no doubt about the authors' views concerning the limits of this program. Given the same time and the same materials, it cannot be compared in effectiveness with the results to be gained from having a competent art teacher. The program is not designed to substitute for a trained teacher. It is designed to perform the function of fundamental art education when no art teachers are present in a school. The evidence suggests that it does what it was designed to do.

The expressed purpose of the series has been clearly stated, and yet the program possesses the potential of serving art education in other ways as well. Where a school district has an art staff, for example, but the ratio of art teachers to children limits visits to classrooms to only once or twice a month, then this program can free specialist teachers from their hurried and infrequent visits and increase their effectiveness by putting their talents and training to better use.

Art teachers could then spend time with teachers who have particular difficulties with art or who have classes of special children—physically disabled, emotionally handicapped, the talented. The art teachers could demonstrate exemplary lessons on which the classroom teachers could model their own teaching. They could also develop exhibits to supplement and enrich the basic program. With this as a core, the possibilities for using their special knowledge and skills in supplemental activities is exciting to think about.

A SYSTEMS APPROACH TO TEACHING THE ARTS

Stanley Madeja

Let us say that a second-grade teacher is planning the arts component of her program for next year. She has conferred with the arts team that services her school and has concluded from the discussions that the instructional sequence in the arts component of the second-grade program should be changed. The emphasis for the forthcoming year should be on the human element in the arts —that is, the artist, the composer, the choreographer, the film maker, and the writer. The resources she has for planning are varied: a set of individualized esthetic learning packages designed for second-grade students that may be arranged in alternative instructional sequences because each module is packaged separately; guidelines for arranging the learning modules in various classroom settings and for a range of instructional outcomes; the school's arts resource team, made up of arts specialists who can suggest methods for amplifying and extending the content and activities outlined in the materials; and a computer printout of the cumulative records, which includes anecdotal data of each student the teacher is to have in class the following year.

Let us also assume that the overall curriculum design that the school has created for its primary arts program has a broad range of objectives, beginning with simple exposure to the esthetic dimension of the arts. Through this exposure, the students will develop a vocabulary to describe esthetic phenomena and will begin to manipulate the interrelationships among aspects of the phenomena by involvement in specific works of art. Building on such exposure and manipulation, the students will increase their awareness of such things as shape, color, texture, and tension and how these are dealt with in the arts, and they will begin to extend their attention to the social significance of art objects, making esthetic judgments about natural as well as manmade objects.

The task of our hypothetical second-grade teacher, then, is to select and organize the available resources to meet these overall objectives and make them relevant to her students. It should be noted that the teacher is not starting from scratch because the materials available provide a substantive base for an esthetic program that eliminates the need for the teacher who is not an art specialist to make key content decisions. The instructional packages have been carefully constructed to expose the students to the essentials of the arts and the esthetic experience, yet the system allows the teacher to determine sequence and classroom strategies as well as extensions and adaptations.

In planning the arts program for next year, this teacher has decided that the overall theme is to be the artist—who he is, what he does, how he does it, and what he produces—and instructional packages on the human role are to be used as the content base for this sequence. The decision to emphasize the human element in the arts at this level was based on the premise that the students should recognize that works of art, or art events, are created by *people* called artists. The bases of decision by the teacher and the arts resource staff for this directional emphasis are that the student population has been changing over the years both ethnically and socioeconomically and that the students and the parents have been demanding a relevant curricular base for the total school program that meets the needs of the changing school population. It was thought that study of the artist as a person and as a producer of art would be an appropriate way to meet this social need and yet not throw out the content. Our second-grade teacher has the opportunity to utilize the content of the program, in this case the artist and how he works, in relation to the value system operating within this particular school system and community as well as in relation to the students' abilities. The teacher also takes into consideration what has been taught in the kindergarten and first-grade programs and how the materials fit into the overall theme that permeates second-grade studies—that of the community and its resources and their interaction.

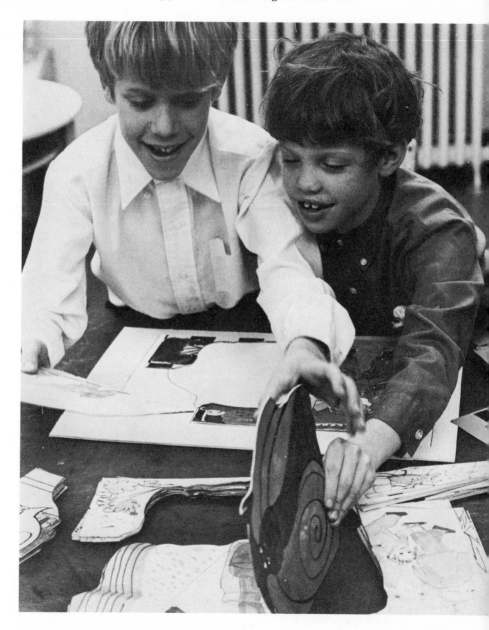

3–1. Children explore the world of the visual artist—who he is, what he does, the materials he uses, and how he creates a work of art.

3–2. A puzzle with interchangeable parts offers multiple possibilities for two boys to create a unique visual image.

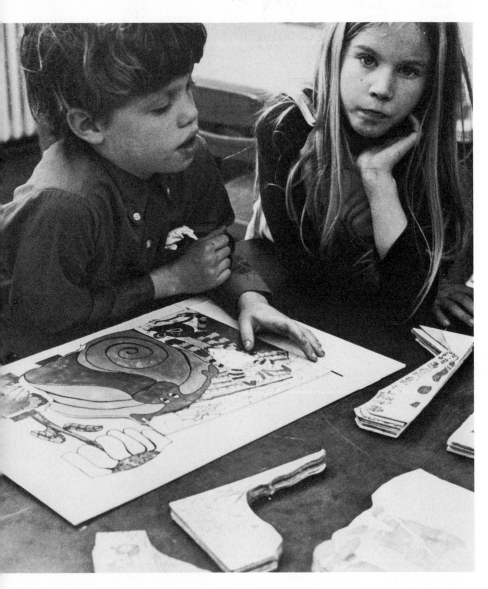

With the community as the overall theme for second grade, the teacher is concerned that the students learn about the esthetic dimension of the community. The instructional materials in the arts, then, are arranged in a sequence suggested in the resource guide to meet these concerns; they start with packages dealing with the visual artist, and then proceed to the choreographer, the composer, the writer, the film maker, and the urban designer, and they culminate in a package that synthesizes the concepts from each of the preceding packages.

Our hypothetical second-grade teacher is in a hypothetical situation, but the materials described are not. Aesthetic Education Program of CEMREL (Central Midwest Regional Educational Laboratory) has used this approach in developing a curriculum that provides an esthetic dimension to the education of a student. The system is designed to provide alternative choices for the student, the teacher, the school, and the school system for arrangement of arts-learning activities, and it is based on the premise that an instructional system is functional only if it provides alternatives for constructing and managing its content to reflect the variety of school populations.

The system is made up of short increments of learning that can be combined into longer and broader learning experiences. The multiplicity of possible arrangements of these learning packages is obviously not infinite but provides enough variation so that the curriculum becomes a flexible sequence in which the teacher and the student have a voice equal in volume to that of the developers of the system. It should be noted that the content of the system is not new but is based firmly in the arts disciplines. What *is* new is that the full resource for developing a curriculum unique to the setting is readily at hand to the classroom teacher or the arts specialist,

3–3. The puzzle offers narrative possibilities as well—"and then the snail took a bite out of the daisy."

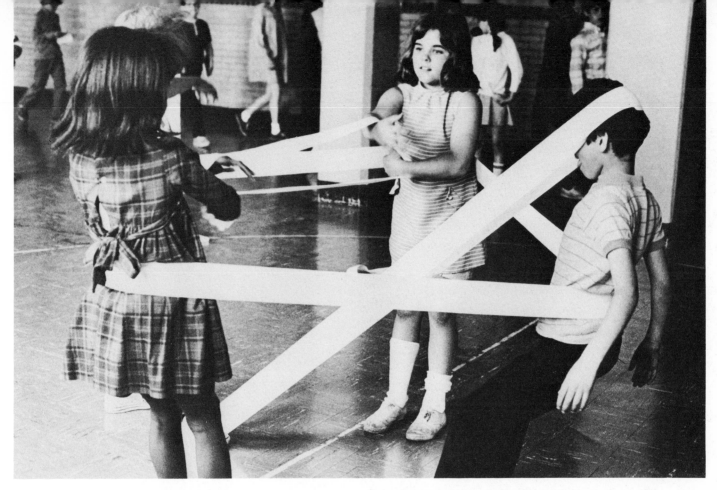

3–4. As an extension of the choreographer package, children explore movement by testing the tension of various materials.

eliminating the tedious tasks usually required to accomplish this goal.

The materials in all the packages described vary according to the arts area dealt with. Printed matter is used where appropriate, as are tapes, films, games, and puzzles. All are graphically exciting, in order to capture and hold the students' attention.

The materials are designed not to replace the teacher but to support instruction in the classroom. The teacher's role becomes more diagnostic and she is free to develop or adapt the materials to the needs of the group. The package also provides a model by which the teacher may develop her own package with concepts and teaching strategies that are relevant to her students.

Each of the packages emphasizes behavior that is characteristic of how persons in each of the art forms work. The initial package, dealing with the visual artist, provides a framework of materials and ideas with which

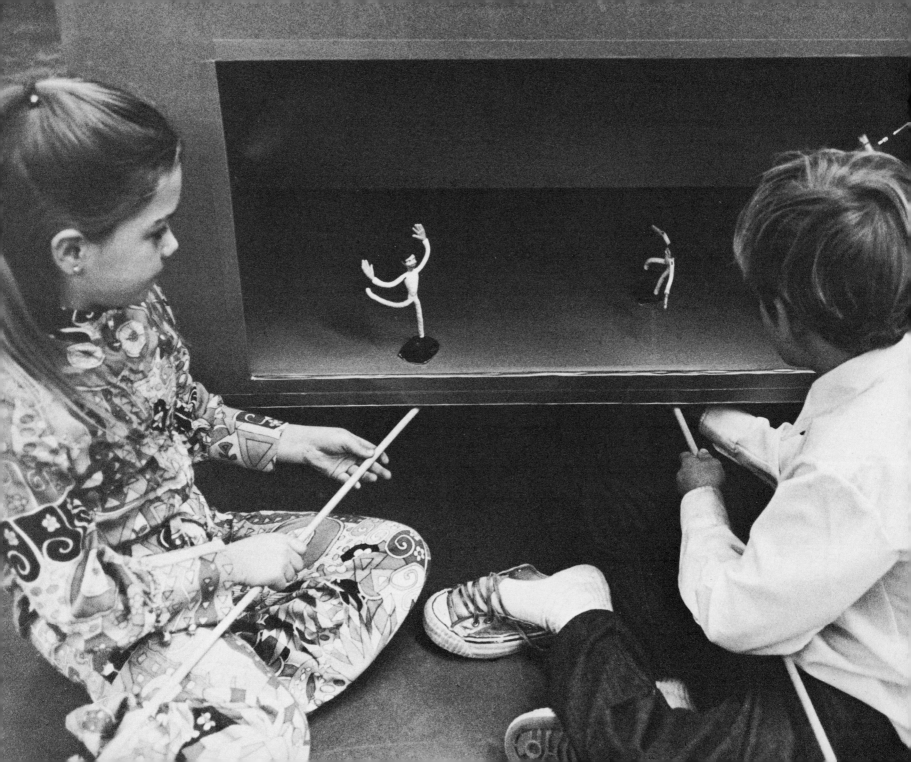

the students define the role of the creator in the visual arts. In working through the activities, the second-grade students should acquire a simple but comprehensive view of who the visual artist is, what he does, the materials he uses, and how he creates a work of art.

A subsequent package leads students through a recreation of the visual artist's activities, taking the point of view that the meaning of any one element of a work of art, or of the whole work, is dependent upon the relationship between it and any other part or group of parts. Thus the artist's decision to change a part of a work affects not only that part but the import of the whole. Materials included in the package allow students to experience this interdependency: a puzzle with parts of like shape but with different images and color combinations on each shape brings the concept within the grasp of the second-grade student.

The choreographer package is centered around a stage box equipped with lights to give students the opportunity to organize a dance performance as a choreographer would. The students are able to manipulate body movement, music, costumes, lighting, props, and sets in the stage box.

In the initial activities in the choreographer package, students are introduced to the choreographer as a person and begin to explore the work that such an artist does. The subsequent activities are grouped around topics through which the students experience the process of choreographing. The first sequence is a slide-tape presentation entitled "I Am a Choreographer," in which the choreographer is defined as "a person who makes a dance." Second, students work with the concept that a creative choreographer must consider the interaction between music, movement, lights, costumes, sets, and props in constructing a dance. Each of these ideas is presented

3–5. Dancers are made to move within the stage box by means of magnets on sticks.

3–6. The composer package involves children in the explanation of sound sources and in the composition and notation of their own musical works, emphasizing the reciprocity between listening and creating sounds.

in one of a series of small group activities. An illustrated book introduces the movement sequence. Then students, using a slide projector for a light source, experience movement with their bodies, developing shadow effects and exploring various movements outlined in the book. Other activities include matching a movement to a musical complement and selecting appropriate costume fabrics from a range of colors and textures. The stage box is then used to explore lighting and its effect on the total dance

environment, while the student keeps in mind the interaction between dancers, sets, music, props, and lighting necessary for a fully realized dance performance. In the final activity the students actually design a dance for the model stage, using the concepts they have learned. The student-designed dance is performed and a classwide discussion follows. As a reinforcement to instruction, the students assemble a portfolio of dance ideas that becomes a part of the assessment component of the package.

The composer package is designed to introduce the students to the decisionmaking inherent in organizing musical elements into an original composition. The score, a tool used by the composer to record a musical decision and by the performer to interpret the composer's musical ideas, forms the basis for the package materials. A series of six activity lessons guides the students as they make composer-like decisions about tempo, meter, rhythm, harmony, and melody. Either the composer-board or a simple notation system may be used to record decisions, and both options are included in the package. The composer-board allows students to record and quickly change their musical decisions with separate notation cards. It also provides for interaction between two or more students in working out a one-, two-, or three-part composition. The students then perform their compositions, using regular instruments, student-constructed instruments, or voice sounds, and they record them on sheets provided in the package. The compositions are then taped and played back so that students may review and judge the esthetic quality of the piece. The culmination is a final written notation of the composition, which then exists as a creative work written and recorded by students.

Similar involvement is encouraged in the activities and materials concerning the role of the writer, the film maker, the urban designer—all building on David Ecker's

3–7. Students receive an introduction to the Space Place.

concept of a variety of models for esthetic behavior such as the artist, the critic, the historian.[1] In addition, the teacher may plan to have her second-graders visit the studio of an artist and to have an urban designer speak to the class. These are outside experiences that amplify the concepts in each package by personal interaction. Visits to the class by a choreographer, a film maker, and a writer are a part of the other instructional sequences.

Another package that can bring the various human roles in the arts together is called the Space Place,[2] wherein students make and carry through esthetic and creative decisions that directly affect the configuration of their environment. A group of elements was developed that is manipulative in nature; children can arrange the elements in various ways, designing their own room-sized environment. The elements consist of flexible ceiling panels that can be pushed up or down to make an undulating upper surface and styrofoam blocks that can be piled up and arranged to create spaces within a space. Opaque and transparent plastic panels can be hung tent-like to create walls and projection surfaces; 35 mm. slides and 8 mm. film loops, commercially or student produced, create various types of visual phenomena within the environment. A tape recorder and a sound system provide options for various sounds to complement the visual environment.

Manipulation of these elements by the students is the basis of the activities. The Space Place allows either free

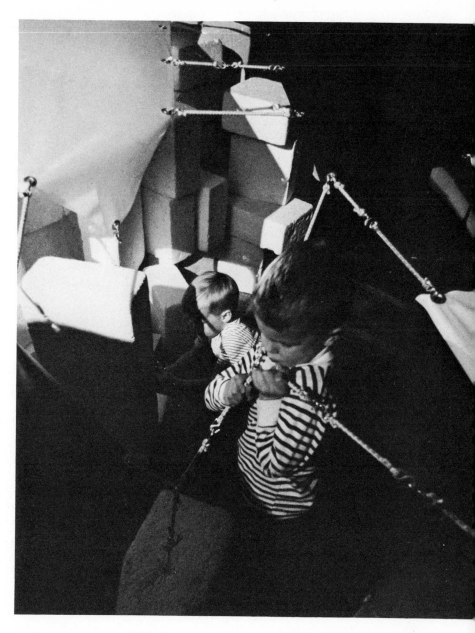

3–8. The Space Place takes shape.

[1] David W. Ecker, *Defining Behavioral Objectives for Aesthetic Education* (St. Louis: CEMREL, Inc., 1969), p. 6.

[2] The Space Place was created by a team of designers: Theo van Groll and Atilla Bilgutay, both of the School of Architecture, Washington University, and the author. The design project was supported by a grant to the University City School District of Missouri, from the JDR 3rd Fund.

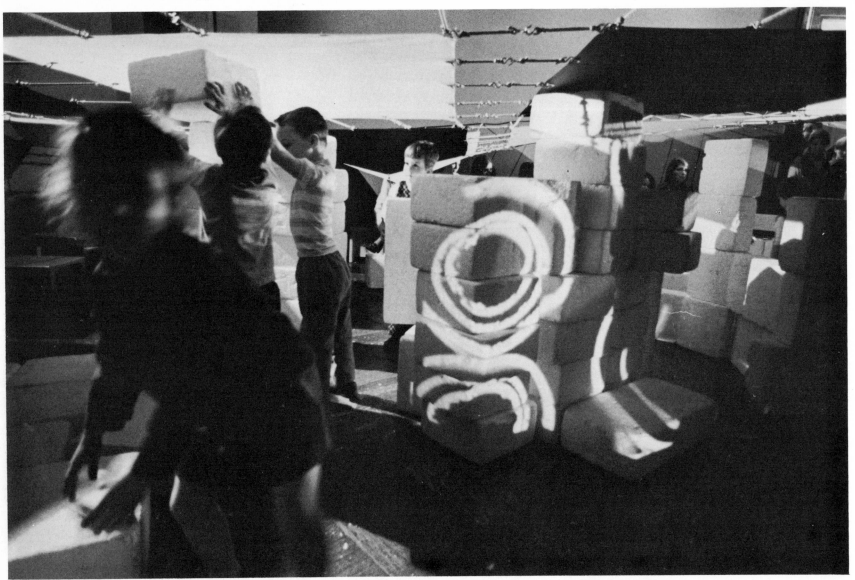

3–9. Swirls of light from slides and film loops complete the visual effect of the Space Place.

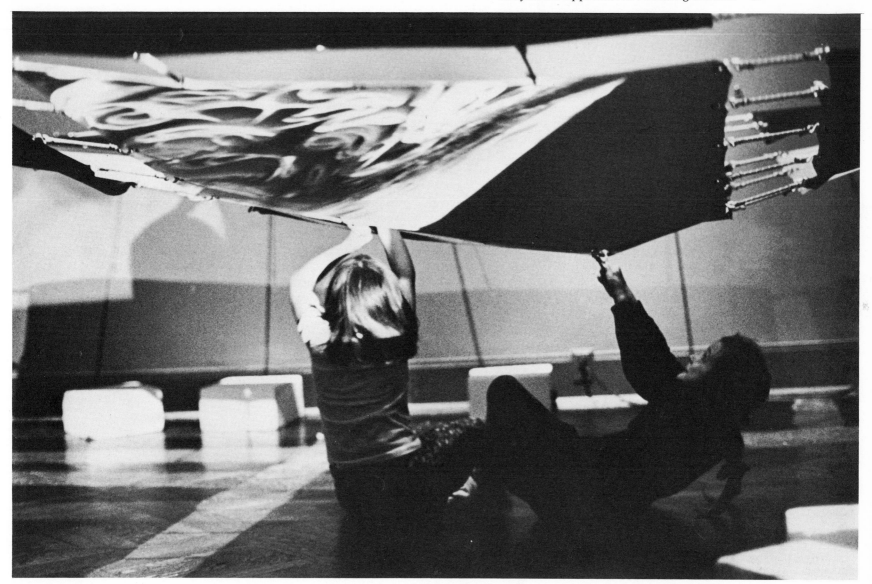

3–10. Flexible ceiling panels in the Space Place allow for free experiential activities, which may vary with the ideas of participants.

experiential activities or a highly structured design problem. The components make an instructional package that is flexible in its construction and that builds upon the concepts learned in the previous packages.

These, then, are the resources available and a general indication of how they can be used. What are the broader implications of this type of program for a school system? Perhaps they can best be seen as analogous to instructional programs now existing in science, where the primary students are exposed to experiencing and manipulating scientific phenomena in many areas—basic physics, basic chemistry, basic biology. Through this kind of exposure, they begin to understand some of the underlying principles of science yet remain aware of the interrelationships of the scientific disciplines. Only in the middle and upper grades do they begin to specialize, as it were, into deeper studies of biology, physics, or botany.

The second-grade curriculum in esthetic education described above approaches the arts in much the same way: the artist in any medium is faced with many of the problems that require the same kinds of decisions but in a quite different medium, and artists frequently must take into consideration many of the same elements of the arts such as aural texture, visual texture, tactile texture. This then becomes the basis for a total arts program in a school system. The disciplines would be strengthened in that students would be operating from a common conceptual base formed in the primary years and would start to make distinctions among the arts disciplines in the middle grades, when such distinctions are appropriate to the students' developmental level in a learning sense and applicable in a functional sense to their ability to define what a discipline really is. This is not a related arts curriculum that amalgamates the arts into one whole; rather, it provides the student with a range of esthetic experiences and choices early in his education that can be the foundation for later specialized programs in the visual arts, music, dance, theater arts, literature, and film. The final goal is that this approach would strengthen a school's arts program for general education and involve more students in highly specialized arts activities throughout the total school program.

ART EDUCATION FOR DISADVANTAGED SEVENTH-GRADERS: AN EXPERIMENTAL APPROACH

Ronald H. Silverman

Late in the 1960s programs were being launched in our schools to help children and youth from the culture of poverty overcome their inability to profit from traditional patterns of schooling. Many of these programs included art experiences among the activities planned for disadvantaged learners.[1] Very few, however, attempted to describe in specific terms either how art education processes were utilized for dealing with particular problems or how the outcomes of the programs were to be evaluated. It was as if a belief existed that because of their essentially concrete, nonverbal nature there was something *magical* about art activities, which, when indulged in, would somehow help poor children to be happier and learn more.

Most of the so-called compensatory programs were initiated from the fear generated by the violence and destruction that has occurred in economically and spiritually impoverished urban ghettos and barrios since August 1965 (the time of the Watts riots). The report that follows describes a project that was being planned before things blew up in Watts. This program was developed on the premise that pupils whose out-of-school experiences differ widely from those of middle-class children should be provided with in-school experiences that acknowledge and reflect these differences.[2] Merely offering a slowed-down version of what is available in the white, middle-class, suburban school was seen as totally inadequate. (For example, relying upon verbal and abstract approaches to teaching and exposing pupils to art forms associated with only Western civilization would not be relevant to learners who have very limited English vocabularies and a non-Western heritage.)

Another premise behind our experimental approach was that one cannot impose a program on teachers. They must be involved in making decisions about what and how they will teach. And, in addition, any innovative materials provided in an experimental program must be reasonable in terms of cost and availability so that other

[1] See Urban Child Center, *The Uses of Art in Compensatory Education Projects* (Chicago: University of Chicago Press, 1966).

[2] The program described below was implemented under a contract with the U. S. Office of Education, Department of Health, Education and Welfare. A complete and technical report (ERIC no. ED 030 707) is available from the ERIC Document Reproduction Service, Leasco Information Products, Inc., 4827 Rugby Ave., Bethesda, Maryland 20014.

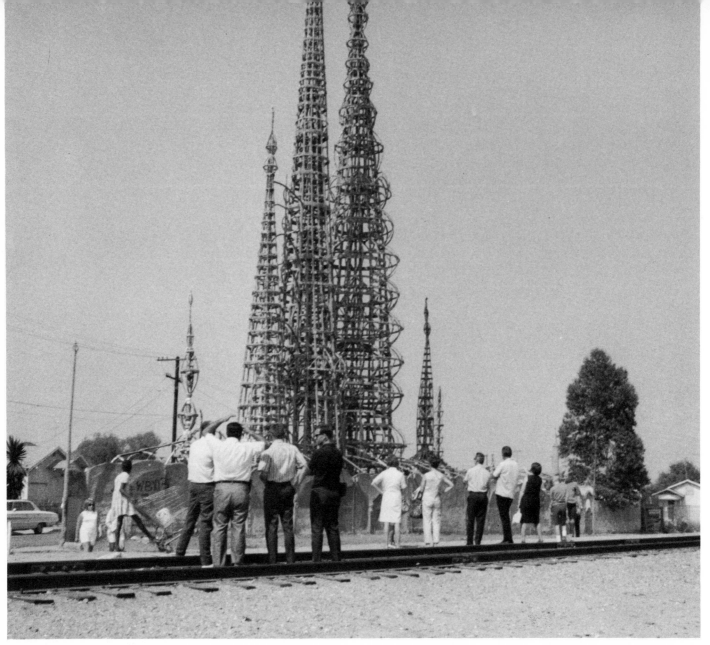

4-1. Teachers in the experimental program visited Simon Rodia's Watts Towers to become familiar with an art form produced essentially from junk that has been transformed into a monumental and moving statement.

teachers working elsewhere can replicate them without great expense or effort.

A third premise underlying our study was that educators would benefit most by our attempts to be very specific when devising and reporting about our purposes and procedures and the devices we used to measure the outcome of our efforts.

PREPARATORY PHASE

After being carefully reviewed by a number of consultants, our proposal for an experimental program concerning art and the disadvantaged was accepted and funded for $60,000 by the U. S. Office of Education in June 1966. A diagram of our study appears below. Our two-year experiment proceeded as follows.

The first year (1966–67) was devoted to (1) identifying and selecting at random seventh-grade art teachers[3] from disadvantaged Chicano, black, and anglo areas in southern California (fourteen were chosen to implement our experimental phase, nine to serve as control-group teachers); (2) gathering information about the disadvantaged and the structure of art and developing curriculum materials and constructing testing instruments that reflected problems of the disadvantaged that might be affected by art education practices; and (3) orienting teachers selected for our program while providing them with an opportunity to formulate teaching plans for the 1967–68 school year.

The second year (1967–68) was devoted to carrying out our program within the schools. At the beginning of the fall and spring semesters, pupils studying with our fourteen experimental- and nine control-group teachers and a group of seventh-graders not studying art at the

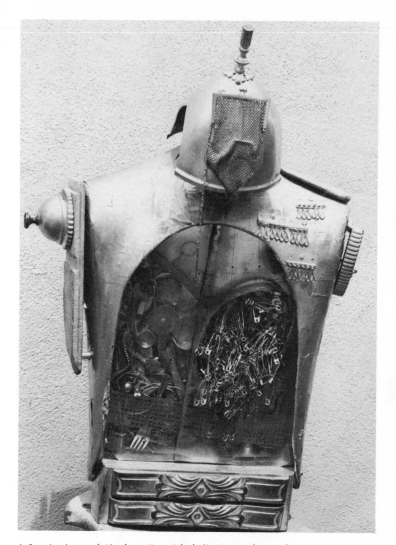

4–2. A piece of "junk art" entitled *Sir Watts*, by sculptor Noah Purifoy, one of the consultants to the program. The work was assembled and welded from junk found in the wake of the Watts riot of 1965. Purifoy used this as an example of the possibilities of "found art" in a discussion with the experimental-group teachers.

[3] Seventh-grade art teachers were selected because in southern California this is usually the only grade in which all pupils are required to take art with an *art* teacher.

time were all tested in the ten areas listed in the diagram. At the end of each semester pupils were tested again, using the same instruments. Some of the results of our evaluation procedures that examined the differences between pre- and post-test scores and their relationship to other variables are discussed at the conclusion of this article.

LEARNING ABOUT THE DISADVANTAGED The first thing that teachers selected to conduct our experiment needed to know was as much as possible about the nature of disadvantaged learners. Such information was gathered from a variety of sources.[4] One of the most important sources was the summary of research on disadvantaged children compiled by Newton Metfessel and his staff at the University of Southern California. Dr. Metfessel's summary includes descriptions of the home and family structures and the personality, social, and learning characteristics of disadvantaged persons. The following is a sample of items selected from this summary, made available to our experimental-group teachers to suggest something of the nature of the students they might encounter in their art classes.

Home and Family Structure. Children from the culture of poverty
1. typically have parents who do not have the language skills to enable them to foster their children's language and cognitive development.
2. typically come from homes where there is a sparsity of objects such as toys and play materials of different sizes, colors, and shapes.

3. typically have parents working at jobs that require little education; this frequently gives the child the impression that school is not particularly important in terms of preparation for life.
4. typically have had little or no out-of-school experiences translatable to the school culture.

Personality and Social Characteristics. Children from the culture of poverty
5. typically are characterized by weak ego-development, a lack of self-confidence, and a negative self-concept.
6. typically have great difficulty in handling feelings of hostility through the use of words rather than force.
7. frequently fail because they expect to fail, which only tends to reinforce their feelings of inadequacy.

Learning Characteristics. Children from the culture of poverty
8. typically have a cognitive style that responds more to visual and kinesthetic signals than oral or written stimuli.
9. typically need to see concrete applications of what is learned to immediate sensory and topical satisfactions.
10. typically persevere longer in a task when they are engrossed in a single activity. Only one task at a time should confront the child. These single experiences should be planned, carried out, and evaluated within a single day.
11. frequently have had little experience in receiving approval for success in a learning task, an assumption on which the school culture is organized.
12. frequently learn less from what they hear than their middle-class counterparts.
13. typically use a great many words with fair precision but not the words representative of the school culture.

Such descriptions as the foregoing plus our understanding of the nature of art activity served as the bases for *hypothesizing* that art activities, when properly organized, could make an important contribution toward overcoming some of the problems of disadvantaged learners. These problems were (1) being perceptually stunted and, therefore, incapable of efficiently assimilating ideas based

[4] Martin Deutsch, "The Disadvantaged Child and the Learning Process," *Education in Depressed Areas*, ed. by Harry A. Passow (New York: Bureau of Publications, Teachers College, Columbia University, 1963), pp. 163–79; E. W. Gordon and D. A. Wilkerson, *Compensatory Education for the Disadvantaged* (New York: College Entrance Examination Board, 1966); Frank Riessman, *The Culturally Deprived Child* (New York: Harper & Row, 1962).

PLAN OF EXPERIMENTAL STUDY

TESTING AREAS

Perception
 1. visual speed
 2. spatial orientation
 3. spatial visualization

Cognition
 4. general vocabulary
 5. abstract reasoning

Attitudes toward
 6. self
 7. authority
 8. use of leisure

Art performance
 9. art vocabulary
 10. draw ability

CONTROL GROUP I Seventh-grade art students taught by art teachers not attending 6-week orientation program. These teachers implemented exploratory and depth curricula in alternate semesters 1967–68.

CONTROL GROUP II Seventh-grade students not taking art 1967–68.

EXPERIMENTAL GROUP I Seventh-grade art students enrolled in exploratory breadth art classes 1967–68.

EXPERIMENTAL GROUP II Seventh-grade art students enrolled in structured depth art classes 1967–68.

Teachers of these students were enrolled in a 6-week orientation program before the start of fall 1967 semester and provided with opportunities to acquire an understanding of the disadvantaged learner and to structure an art curriculum designed specifically to meet his needs. All control and experimental groups were located in schools within areas eligible for poverty relief funds.

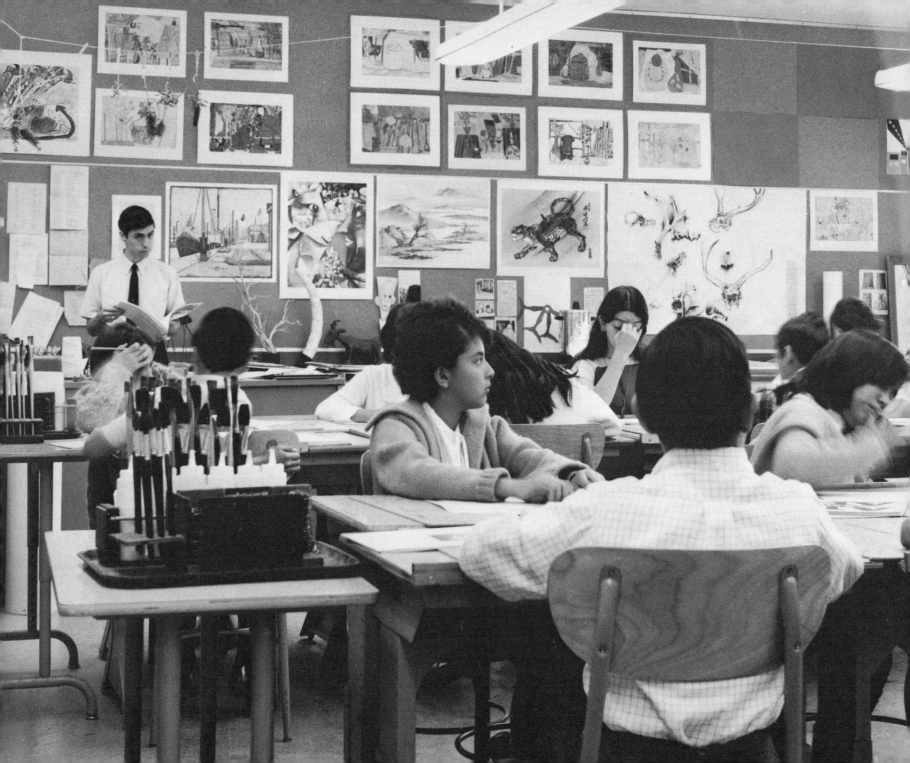

4–3. Scenes in the experimental classroom. Note the use of historical art contexts and the attention paid to mounting and organization of art supplies.

upon a clear perception of qualities such as shape, size, texture, color, scale, and dimension; (2) suffering from poor self-image (that is, not being clear about one's identity and lacking motivation because of doubts about one's worth); (3) being deficient in the acquisition and use of in-school vocabulary; (4) being object-oriented and lacking an interest in ideas and abstractions (two of the major characteristics of school subjects beyond the sixth grade); (5) failing in school and in life and, as a consequence, being hostile toward all forms of authority; and (6) using leisure time passively and in other ways that are counterproductive to achieving success within our schools.

LEARNING ABOUT THE STRUCTURE OF ART Gathering the visual-arts teachers together to inform them about their disadvantaged pupils presented an opportunity to refresh and update their knowledge about the subject they teach. To provide such information, a series of questions was put before several experts. A résumé of their responses, which was made available to the experimental-group teachers, is as follows.

1. How would you define the phrase "structure of art"?

 Ordering the esthetic elements of color, form, space, value, and line into a visual whole that expresses the unique aim, idea, or intent of the individual artist.

 Ordering the visual elements in terms of the requirements of assignments and the nature of reproduction processes.

 An individual view of how form is organized but with a primary concern for understanding the materials to be employed.

2. What concepts related to this structure do you believe are most fundamental?

 That art is *constructive*, possesses cultivated, expressive, and clarified *content*, evolves through a *medium*, and culminates in a unique form.

 Knowledge of the consumer, the marketplace, and the requirements imposed by particular reproduction processes and how the product is to be seen or sold; viewing time available.

Material-form relationships; the imposition of materials upon scale; form-function relationships; part-whole relationships; consciousness of the past.

3. What concepts related to this structure do you believe to be unique to particular branches of the visual arts?
 Painting: color as form, the presentation of space as a relation between color patches.
 Sculpture: real space, line as intersection of planes, relationship of masses; negative space, a balance of tensions between bumps and holes.
 Drawing: the ambiguity of a line, contour line, quality, the trace of movement, represented space.
 Architecture: organization of masses with livable negative space; the object as synthesis of outside and inside; living function most important element.
 Crafts: synthesis of form and function; subservience of "decoration" to the successfully functioning form.
 Art history: understanding the function of the esthetic elements in historical works.

4. What activities do you believe are of greatest importance in developing awareness and understanding of the structure of art?
 Visual perceptual learning: recognition of the visual qualities in our environment as nonverbal communication; comparison of visual with other art forms; understanding past and present roles of artists in our own and other cultures; recognition of a variety of contents and styles; awareness of visual qualities in natural forms.
 Learning art-related behavior: cultivation of the capacity for an esthetic response; examination of opinions and values as a basis for art judgment; intuitive development of resourcefulness and imagination; responding uniquely to art experiences.
 Visual organization learning: arranging the visual elements in relation to principles; being familiar with a variety of media and processes; experimentation with only one medium; visual expression of ideas, attitudes, and feelings; developing a sensitivity to the unique demands of each art form.

5. What sequence of learning experiences, from the least to the most complex, would you prescribe to enable learners to acquire an understanding of the structure of art?

Learning to respond to qualities in works rather than historical data; learning to make surface discriminations (color-line, nonobjective works, comparisons with other art forms); conceptualizing the relation of objects seen as ideas (this must be divorced from the significance of the surface used to present the idea or object); abstraction, or the recognition of theme attributable to the artist's manner of constructing the surface.

6. Are there certain works that you identify as being of singular importance to the evolution of the visual arts?
 The significance of a work of art represents the discovery of perceptual quality on the part of a person manipulating materials, which is then communicated to others who are open to the influence of their environments. The proper esthetic concepts are more important than knowing the history surrounding "masterworks" of art.
 Exemplars of esthetic forms should be sought out in one's own environment, ranging in significance from examples of city planning to examples of ceramics and metalwork.

7. What are the sources for your expressive works?
 Nature is a basic source of information and inspiration. Medieval forms produced by people who were directly connected with their materials are also a source of stimulation.
 I produce art to dispel my own anxieties, for I am guilty of not making the world "better." I must justify my existence through being productive; I make an object I can see and "grow up behind." Social protest and good and bad art are also motivators. The reactions of people to me and what I produce are important sources.

8. How do you function as your own critic?
 Deadlines are an important variable affecting the nature of self-criticism, as are the requirements of the client, the marketplace, and the processes of reproduction. The compulsion always to produce something different also enters into the evaluation of my work.
 Analysis based upon how well the object created will function physically, liturgically, and esthetically.
 Elapsed time is a most important variable; an incubation period makes it possible to be more

objective. By working on several pieces at one time, I can let what is happening on one of them provide insights into another.

ACQUIRING AND DEVELOPING RELEVANT CURRICULUM MATE-RIALS The information gathered about disadvantaged learners and the structure of art also served as the basis for developing an experimental textbook, *All About Art*, organized and printed specifically for our program. The purpose of *All About Art* is to present information about art to seventh-graders in a very basic way. The book is divided into five parts with part titles posed as questions: What Is Art? Who Makes Art? What Are the Sources of Art? Why Is Art Important to You? Why Is Art Important to Society?

All About Art was planned to enlarge pupils' vocabularies by capitalizing unfamiliar terms in the text and underscoring phrases nearby that serve to define the terms. To help improve the pupil's self-concept, the artists and works included in the text often bear a relationship to the pupils' racial or ethnic heritage. To provide a basis for discussing how one's environment influences behavior, special emphasis was placed on the role of culture as an influence on works of art.

At the end of each section of *All About Art* ten questions are listed that require the pupil to recall what he should have learned about art. These questions are given here to help make clear something of the contents of our experimental text.

What Is Art?
1. What is mean by the word VISION?
2. How do the tools and materials used by artists make a difference in the way an art object looks?
3. What is meant by the word COMMUNICATION?
4. What hapens to you when you are REACTING to an art object?
5. When is a useful object also an art object?
6. What does art have to do with our BASIC NEEDS?
7. What is meant by the words MASS MEDIA?

8. Where do we find art objects that are very old and very valuable?
9. Why are art objects that we cannot use still valuable to us?
10. What is the main difference between painting and sculpture?

Who Makes Art?
1. What are some of the things done by artists called designers?
2. What do designers need to know when they are planning a functional object?
3. What is the artist called who also makes the art objects that he designs?
4. What are some of the purposes for which craftsmen make objects?
5. When can a photographer also be an artist?
6. What does a photographer use to produce art?
7. How does an artist TRANSFORM junk into art?
8. Sculptors are artists who work with what kinds of materials?
9. How many things that you see every day can you name that were planned by people who might be called artists?
10. Why can designers, craftsmen, photographers, and people who make things out of junk be called artists?

What Are the Sources of Art?
1. What is meant by the word CULTURE?
2. Why do art works made by artists in different parts of the world look different?
3. What is a LANDSCAPE?
4. In what ways can the materials used by the artist act as a source for his ideas?
5. What is the word used to describe art that uses as its subject what appears to be impossible?
6. What is the art called that uses dreams for its source of ideas?
7. Why is art itself the most important source for the artist's ideas?
8. How do functional needs influence what will be made by artists called designers and craftsmen?
9. In what ways can art from other cultures affect the art of our culture?
10. What are two things that an artist does which make it possible for him to produce art?

Why Is Art Important to You?
1. What is there in an art object that does not appear in a nonart object?
2. What happens if you only look at an art object and do not study it?
3. Why must you concentrate on an art object?
4. What are some of the differences between visual order and visual confusion?
5. Why is it important to live in a visual environment that is well organized?
6. Can you name several things or places in your own neighborhood that are well organized?
7. Why should you learn how to make art?
8. What three kinds of art object would it be possible for you to make?
9. How is it possible to make art out of scrap materials?
10. What is the most important thing to think about as you are making an art object?

Why Is Art Important to Society?
1. What can be learned about the past by looking at objects called art?
2. Why is it important to know about the past?
3. How can art objects you have made in the past help you improve what you will make today?
4. How does art make it possible for you to share experiences with other people?
5. Why is it important for people to have many experiences that are the same?
6. What can you learn from the art objects made by people who are very different from ourselves?
7. Why is it important to understand the art made by people from other cultures?
8. What does the term CREATIVE mean?
9. Why are ORIGINAL works of art important to society?
10. Where and how can you find art?

Teaching art effectively requires the utilization of visual materials. Each of our experimental-group teachers was provided with fifty reproductions. The teachers developed an information sheet for each reproduction that contained materials about the work itself, something of the artist's biography, and five questions about the piece phrased in terms that would be meaningful to their pupils. Many of the pictures in *All About Art* illustrate the same works of art. This made it possible for teachers to show the pupils a full-color enlarged image of the work of art being discussed in the book.

The teachers of our experimental groups were also provided with sufficient numbers of pre-cut pebbleboard mats to allow each pupil to take home at least one of his works carefully matted and ready for display. It was hoped that this would serve as a means for the pupil to receive recognition for his efforts and thereby contribute to his sense of self-worth.

ORIENTING TEACHERS During the summer of 1967, a six-week seminar was held to prepare teachers to implement our program. Visiting consultants informed them about the nature of disadvantaged learners and possible strategies for dealing with their problems and the nature of art and the possible ways of organizing art curricula so that teaching would be more effective. The following is a listing of some of the ideas presented by our visiting consultants during the seminar.

1. Dr. Florence Diamond (psychologist and evaluator of the Pasadena Art Museum study on the disadvantaged). The "smorgasbord" art-activity approach does not appear to be appropriate for disadvantaged children. A highly organized environment is essential to minimize confusion and distraction. Three-dimensional media may be most important.

2. Dr. June King McFee (head of Institute for Community Art Studies, University of Oregon). Art objects can be conceived as culture-carriers; they project images of the culture. Many disadvantaged children are from rural areas, and to learn how to live in an urban environment they need to understand a vast array of symbols, ethnic symbols as well as those found in the mass media and fine arts. Art forms must be related to students' immediate experience; art appreciation should be taught

4–4. An example of the drawing aptitude test administered at the beginning and at the end of each semester. Students were asked to draw the branch, and their drawings were evaluated in terms of ability to handle the medium, to produce variations in values, and to compose a unified statement.

within a social context rather than a historical one. What is happening between the child and a work of art should be of prime importance. Students need to understand the differences between order and disorder and they need to be taught directly why they are in school.

3. Dr. Eugene Grigsby (professor of art, Arizona State University). Art is employed in many societies to maintain cultural norms; it serves as a means of social control. In tribal art, the major influence upon the forming of objects was the physical environment, both visually and materially. African forms influenced many Western artists—Nolde, Kirchner, Matisse, Vlaminck, Braque, and Picasso. The time was ripe for such an influence as a consequence of Gauguin's turning toward primitive and basic approaches.

4. Mr. Reuben Holguin (Office of Urban Affairs, Los Angeles City Schools). Teachers should not feel sorry for the disadvantaged; they should display genuine concern by challenging their students educationally. Students need to learn that art is not merely fun or play; it is important work. Parents and students need to realize that Mexican Americans, as well as others, can also be artists and earn a living as such. A stereotype exists among many art teachers that Mexican Americans appear to be of three types—newly arrived; second- or third-generation Americans; and the "viva-mexicano" who is still very much concerned with Mexican traditions.

5. Mr. Noah Purifoy (painter, sculptor associated with Arts Joined for Watts). Producing art is a means of dispelling anxieties; art provides something to "grow up behind." What one produces is an extension of himself. Junk art is creating order out of things that others have thrown away; using junk is an activity that relates most to man because the medium itself has been used for some human function, but junk needs to be transformed so that a statement is made that goes beyond what the junk object itself represents.

6. Dr. Manuel Barkan (professor of art education, Ohio State University). This experiment is concerned with examining, among other things, the controversy between two approaches to art education, which can be characterized as follows: (*a*) the exploratory or breadth curriculum (concepts and processes occur sequentially, one after the other, without extensive back-reference; the principal orientation would be a focus upon the execution of a wide variety of art projects of relatively limited scope and time requirements); (*b*) the depth art curriculum (concurrent relationships between and among concepts and processes would be emphasized; the principal orientation would be a focus upon the extended attention to and examination of concepts associated with the visual arts). Art activity can be construed as making art or talking or reading about art or examining works of art. Every work of art appears to possess the following qualities—attention to a subject, theme, or an idea about visual structure that is executed in some medium utilized in some way that in turn assumes a particular form that expresses some kind of style or cultural idiom.

PLANNING WHAT WILL BE TAUGHT　One of the most important phases of our six-week seminar was providing teachers with an opportunity to organize the information they had acquired into a weekly plan format, which in effect served as an outline for what they intended to teach during the coming school year. Because of the controversy over depth and breadth approaches, each teacher was asked to formulate both a depth and a breadth plan.

Teachers who were to work with our control groups met for two weeks preceding the opening of school. They were also oriented about the depth-breadth issue, but they were not provided with any information about disadvantaged learners or the structure of art nor did they receive copies of the experimental textbook or any reproductions. They were asked, however, also to formulate both depth and breadth weekly lesson plans.

THE PROGRAM AND ITS RESULTS

Our fourteen experimental- and nine control-group teachers implemented their programs during the 1967–68 school year. The overall program involved well over one thousand students. Each experimental-group teacher used the information and materials acquired during the summer in his or her own way. Since the teachers were selected at random from fourteen different school districts, they represented a cross-section of those who were teaching art to disadvantaged seventh-graders. As the following findings will indicate, some were more effective than others in bringing about improvements in the behavior evaluated in our program. Even though each teacher taught one semester from the breadth plan and one from the depth plan, when we compared the pre- and post-test performance of the pupils and correlated changes with what we knew about our art teachers, it was the teacher variables that appeared to have the greatest effect upon pupil performance.

THE EFFECTS OF TAKING ART IN THE SEVENTH-GRADE After comparing pre- and post-test scores of pupils who had not taken art with those who had (under both experimental and control conditions), we found that being in a seventh-grade art class over a period of one semester results in a significant growth in ability to make rapid and accurate visual discriminations, as measured by our visual speed test. Although this is an important finding, it was the only change produced by merely being in an art class.

THE VALUE OF OUR EXPERIMENTAL PROGRAM We found that pupils studying with a teacher who had attended our six-week orienting seminar (and who had been provided with our experimental text, reproductions, and pre-cut mats) made greater improvements than their control-

group counterparts on our spatial-orientation aptitude test, in positive attitudes toward parents, as measured by our attitude scales, and in their performance on our art vocabulary test.

DEPTH VERSUS BREADTH TEACHING The depth approach to teaching art, whether under experimental- or control-group conditions, resulted in greater improvements in spatial orientation aptitude and in the ability to formulate sophisticated abstract concepts. Participation in a breadth program appears to produce more mature attitudes toward stress situations, at least as measured by our attitude scale.

TEACHER BACKGROUND AND ABILITIES We found that teachers who had taken the most units of art and had the most years of experience in teaching the disadvantaged were able to bring about the greatest improvement in the ability to draw. And, within our experimental group, such teachers also brought about the greatest measure of growth in visual speed and accuracy and an increased interest in domestic mechanical leisure-time activity. The teachers' abilities to formulate adequate lesson plans were related to growth in spatial-orientation aptitude and, in the experimental group, to increased understanding of art vocabulary.

CONCLUSION

Our study has demonstrated that one cannot assume that art education practices are profitable experiences for the disadvantaged simply because of their concrete, nonverbal nature, as many appear to believe. We found that teaching for more specific changes is essential. That is, information about the disadvantaged and the structure of art, the availability of relevant texts and illustrations, and utiliz-

ing an in-depth approach to teaching are important variables. But the most salient insight our study provides is that it is the art teacher who is the key to bringing about behavioral changes in disadvantaged learners and not art per se. Thus, investing in the art teacher—enabling him to acquire the information and tools to do the job and providing the time needed to pull his ideas together in a systematic manner—should result in a valuable contribution of art education to the formal education of children and youth from the culture of poverty.

EXPANDING THE BOUNDARIES OF ART: ART AND GENERAL LEARNING

In the following section, Margaret Bingham and Don Brigham, like Lowry Burgess and Rita DeLisi in the next, are not interested in art as an autonomous area of instruction. Their programs emphasize art as a means of more effective access to other areas of the curriculum, to general cognitive development, or to the total sensory apparatus of the child. In the programs described, art exists more for its potential as an aid to general learning than as an end in itself. Thus the product of the artist is exchanged for the perceptual and creative processes that can move a child away from the apparent limitation of the art object.

As Burgess and DeLisi do, Bingham and Brigham opt for the total personality and intellectual growth rather than an accumulation of knowledge and skills. Of course, most art teachers would claim that art as a separate discipline is perfectly capable of accomplishing the same ends, and therein lie the seeds of some future debate. Is art debased when used instrumentally?

When DeLisi designs a sequence of activities around such ideas as tension, movement, and organic relationships, her arguments are obviously closer to Brigham and Bingham's activities than to Hubbard and

Rouse's plaster decorations or Silverman's drawing activities. The sources of ideas in the following programs are also significant; although most art teachers use the artist as model, Bingham and Brigham rely upon the findings of learning theorists (Piaget, Woodruff, Bruner, Arnheim) for clues as to how the education of vision can more readily facilitate total learning. The child as ideal learner has supplanted the artist as model and, if the materials of the artist are still at hand (as they often are), their context has been notably altered in the service of some other purpose. This also takes the art program even farther afield than conventional correlative or integrated art approaches. Thus a mural or a weaving based upon the culture of the American Indian suddenly emerges as a rather standard art activity when compared with an exercise in visual analogies.

If a general-learning approach seems threatening to most art teachers, they can rest assured that it will become a problem only when art schools and college art departments begin training for total learning rather than for art learning. At present there is little evidence that this is happening.

LEARNING DIMENSIONS: A CHANGE MODEL FOR THE ELEMENTARY SCHOOL

Margaret Bingham

What happens to our children
When papers clog sewers,
When cans and bottles strewn on streets
 Reflect endless nights?
What happens when big guys bop little guys
 Just for kicks?
What happens when baby batters pans,
 Trying to fit one inside another?
What happens when he's stopped?

What happens when boy's question about the world
 Is answered by "shut up!"?
What happens when girl comes to school
 With ragged clothes,
 Scaly head, sore mouth
And tries to understand
 What's meant by one plus one?

What's one?
What's plus?
Is there ever a plus?

Poor urban neighborhoods such as the ones in Philadelphia are where school administrators are consistently faced with rock-bottom scores on national norm tests. These tests, while far from being the most valid measuring devices for what children can do, seem to reflect the fact that many poverty-ridden children are not learning to read or write let alone to interpret, compare, analyze, or create. The forces of home backgrounds affect children who come to school at age five with perceptual or emotional difficulties, often due to little experience playing with toys and simple games, counting, hearing stories, or exploring with adults. This tends to result in children who are not cognitively or emotionally prepared to accomplish the tasks that are traditionally the fare of the elementary grades. They have great difficulty learning to read, write, work with numbers. They are often afraid to create something on their own for fear of meeting disapproval. Each type of learning needs a great deal of preparation for it to develop, mainly in the form of working with "things"—water, blocks, puzzles, clay, paint—as well as many opportunities for discourse with adults and other children.

The Learning Dimensions Program presently in two Philadelphia elementary schools, K–6, is in a neighborhood with all the characteristics of any poor urban section. The main purpose of the program is to find ways of helping turn the trend in these two schools away from hopelessness by acknowledging and responding to some of the children's needs. Perhaps if alternate ways of helping children to learn can be found in these schools, with children from multilingual and poverty-ridden back-

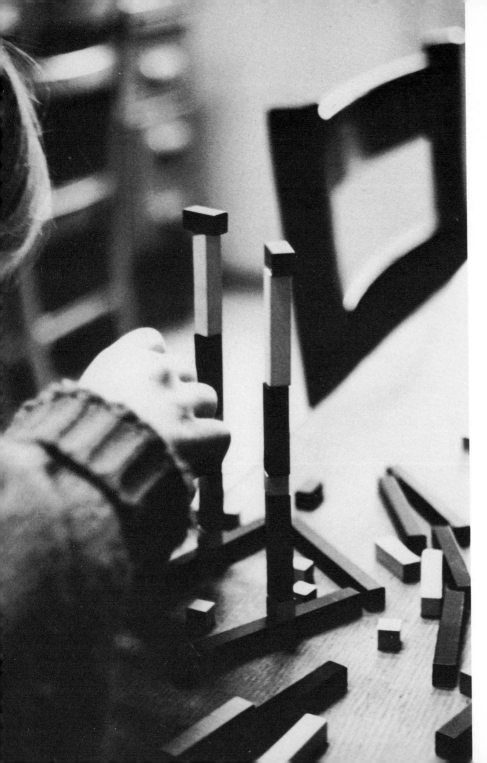

grounds, the approaches can be replicated for use in other schools.

It is not an "art" program in the conventional sense. It is not even an arts program, as it was once intended to be. It has developed into a program that focuses on the learning process of children from five to eleven years old.

The main emphasis is on staff development that aims at helping teachers see reason to change not only their methods of teaching but also their relations to children and other staff members. Involvement in the program also asks for significant role and priority changes by principals, specialists, supervisors, and superintendents.

The seeds for the Learning Dimensions Program were sown when a K–12 visual arts program in a large suburban school system was, for all its strengths, viewed as less than effective in the total learning process. "Art" was separated from "basic" or academic subjects and became, as is often its fate, a nice thing to have but a "frill." Art became a function of only the art teachers. This left other teachers "free" to teach the "basics."

The problem seemed to call less for a frontal attack to force the arts into the total curriculum than one that would eventually get to the problem in a less obvious way. Perhaps the emphasis should center on *who* was learning and *how* learning takes place rather than on *what* was being taught. After all, the sciences and math late in the 1950s were being reorganized in terms of *who* was learning. Were their goals really any different from those of the arts—to have a child organize his own experiences so he can learn not only the data of a subject but also the processes peculiar to it, such as number systems, or the relationships among living things or how things work? Mathematicians were saying that if a child is asked to find as many ways as he can of making "five" by using blocks or rods or whatever, he will "discover" for himself all the possible combinations. The data about "five" is

5–1. Cuisenaire rods are highly structured mathematical learning materials. They mean little until a child has played, experimented, built with them.

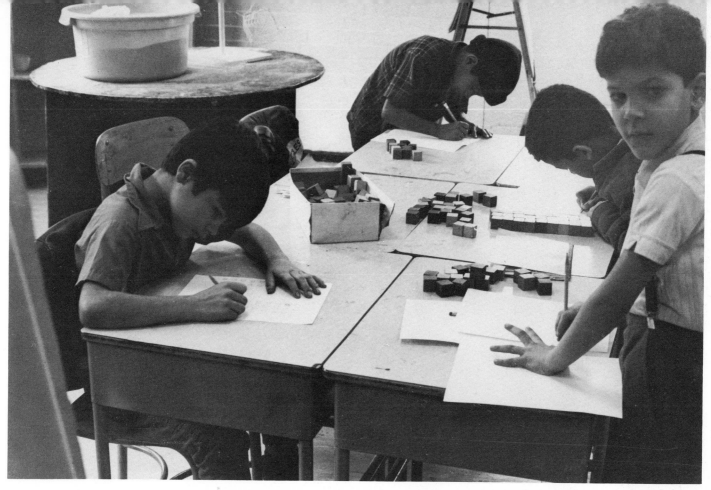

5–2. Recording number patterns found by using colored cubes. Addition, subtraction, division, and multiplication can be more readily understood through visual and kinesthetic manipulation.

therefore learned by the child searching it out rather than by his memorizing it for its own sake. The important thing that evolved was that "discoveries" of patterns and relationships are as new to the child as they were for the first person who discovered them. The implications for teachers were that they not only had to ask children the kind of open-ended questions that would lead them to discover more patterns but also to structure activities so that each child would be free to explore within a framework that is clear and meaningful to him.

Two major influences on the formation of the style of the Learning Dimensions Program were Montessori and the work in English primary schools with activity-centered learning. The major theoretical influence on the program's formation is the work of the Swiss developmental psychologist Jean Piaget. His studies of children of all ages have produced a complex but revealing theory of learning. He deals with how our action on new information leads to learning it by our organizing it—classifying, ordering, matching, verifying.

5–3. Large pieces of wood can be recombined in endless ways. With the help of good questioning, children develop ideas about shape, balance, force, and tension.

Piaget also recognized that learning is distinctly different as we mature. Differences are defined in stages, each of which has certain characteristics. For instance, a child of four who sees the same amount of water poured into three containers of different sizes and shapes would be fooled by the appearance that there is more water in a tall, slim container than in a short, fat one "because it looks taller." To a ten-year-old it might seem obvious that, no matter what it looks like, the same amount of water is in each container. A child of seven might have difficulty telling someone else what he has just done, while a child of eight or nine might have little or no difficulty. There are two profound implications about learning that emerge from Piaget's theory: one is that no two people adapt or learn information at the same rate or in the same way. The other is that skills of thinking develop only when we work with and organize concrete objects for ourselves.

If activity is important to learning, then the arts must have a crucial role in the total learning process because of the activity involved in learning about them. If thinking instead of reading becomes a major priority, which urban educators aim at helping children to develop, then the creative experiences associated with the arts, humanistic interaction associated with exchanging ideas, and comprehension of what one is doing and reading must be the threefold approach to a total educational package, from five years on up.

How, then, must classrooms change? Ask some questions. Do they provide for constant opportunities for humanistic interaction, talking, explaining, questioning, among adults and children? Do they consistently provide a rich variety of objects that children can group and regroup? Do they provide opportunities and space for children to build constructions, paint pictures, write poetry, explore familiar materials that they can put together in new ways? Do they provide opportunities for children to comprehend by listening, explaining, writing about and reading their own experiences, which mean more to them, at first, than reading what someone else has written? Do learning experiences go beyond the classroom walls into the environment and the community that school is a part of?

There are obvious difficulties when teachers begin asking such monumental questions. Almost all have been educated to believe that the teacher, like the customer, is *always* right. Now they are not only being asked to change their value system about the relationship of teacher to student; it is also suggested that they can learn at the same time that students are learning. Classrooms will often be noisy. More time will be needed to organize and write activity cards and plan. Activities need to be structured so that children will see purpose in what they are

doing. The people in the room will not be in the same relationship for very long within any time span because of the constant and purposeful changing, choosing, trying. It is far from a laissez faire atmosphere and offers no hopes for easier teaching.

Staff development of the Learning Dimensions Program is seen as the major thrust, the major need. The program advocates as the "how" the open classroom and integrated day, the "what" subjects integrated around the interests of children (with the arts equally part of children's learning experience), the "when" related to Piaget's studies of cognitive levels of development. The three central goals then become to (1) make the child's learning processes the center of our concerns, (2) help teachers and school staff make the transition from teacher-directed to activity-centered classrooms, and (3) help teachers, aides, administrators, and specialists identify the learning process in all types of activity.

In order to do this, staff development consists of (1) working with teachers in classrooms to help them focus on their own children in an activity-centered setting, (2) miniworkshops for content inputs (one-and-one-half-hour workshops during the school day by grade levels in math, science, visual arts, and so on), (3) small group conferences related to writing task cards, applying thinking skills to every aspect of the child's learning, applying reading techniques in an activity-centered classroom, evaluating each child's progress, asking questions without giving too much information, (4) large weekend and summer workshops on Piaget's theories as related to how children think, the arts as related to problem solving, and group interaction analysis.

What we hope to accomplish by this staff development framework is fivefold: (1) the teacher's insights into how children learn begin to shift; therefore, questioning of children is more in tune with their needs; (2) the teacher begins to merge reading and the arts and the logical or mental operations; (3) the teacher begins to

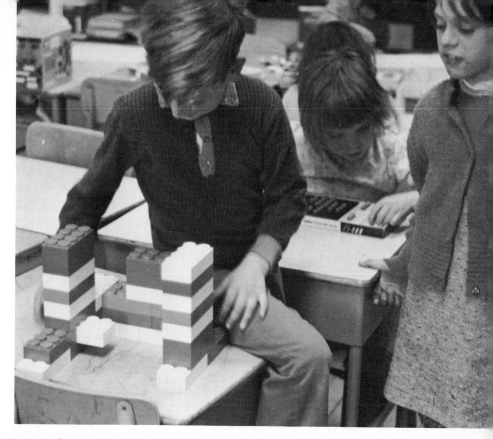

5–4. Enclosing space, opening space with construction blocks encourages seven-year-olds to organize their thinking in ways that help them to deal with abstractions, numbers, and words.

pull larger ideas together by means of the mental operations for developing thinking skills, the arts for developing sensory awareness, the language arts to develop comprehension skills; (4) the teacher sees how to involve pupils in planning; pupils begin to see what questions to ask as they work out ideas gathered from working with things; (5) the teacher sees that pupils' use of activity cards, the arts, and independent reading are aimed at helping each child make choices and decisions that will enable him to become an independent, thinking human being.

We have found that there are many concerns that teachers discuss during the changeover process. Many

5–5. A student measures a page to make a tangram puzzle. Matching, scale change, and measuring are the beginning of observational skills often used in drawing.

questions at the beginning are related to the upset in organization that inevitably takes place. If a teacher is at all experienced, certain routines and pacing have developed with children that give the teacher assurance that there is control in the classroom. We ask that teachers relearn certain organizational processes; there will be movement and more noise than usual and activities will have to be structured for each section of the room. In addition children will have to be taught how, when, and where to use supplies and equipment. Once new structural or organizational patterns are worked out, teachers begin to realize that they are asking closed questions. The difference between "What two colors make green?" and "How many different kinds of green can you make?" makes the difference in how much leeway there is for a child to explore the possibilities. In-depth looks at the once-familiar subjects reveal that there are layers of ideas that have never been explored in math, science, the arts, and the social sciences. Teachers begin to ask questions such as "How can I know what to ask if I don't know more (science or math or whatever)?" Teachers also begin to realize that it is not only more they might know but also how to put content into the framework of Piaget's theory; how to ask questions and organize materials that lead to real thinking by the children. An evaluative stage sets in when teachers examine, alone and together, what works. They begin to feel the power of their teaching and, by the last stage, are consistently creative in how they work with children; they begin to find it much easier to relate content to each child's individual needs and pacing.

If a school staff develops skills in classroom organization with activity centers, knows how and when to ask questions of children, and finds ways to evaluate them, it

5–6. Visual stimuli are used to develop language skills. Children begin to write by comparing two reproductions of paintings, the teacher acting as a resource by writing words that the children want spelled.

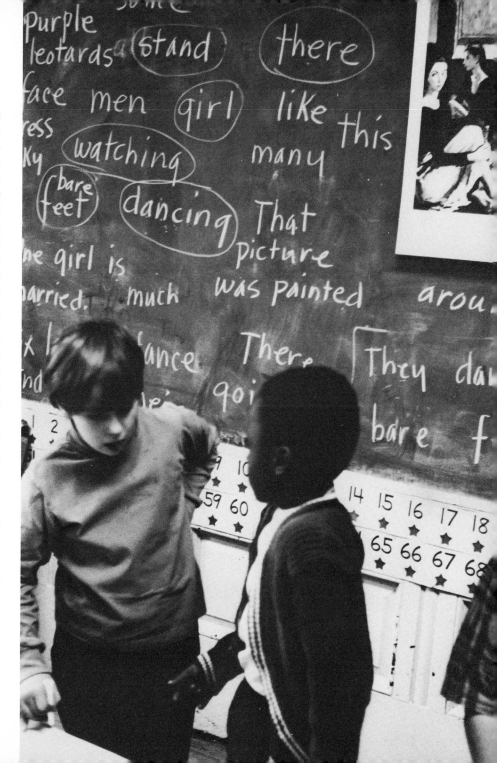

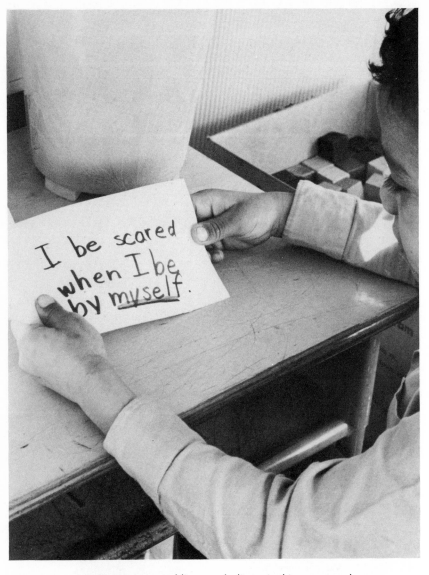

I be scared
when I be
by myself.

5–7. A six-year-old's own feelings, in his own words, are recorded by the teacher—something that is possible only with mutual respect between child and adult. The card is copied into his notebook and he is asked to find his sentence the next day.

has moved a good way toward being able to start working with an entirely new staff on a one-to-one basis—to help another staff meet the anxiety of having to reevaluate and reorganize its approaches to learning and teaching.

The Learning Dimensions Program staff considers its major role as providing a support system for school staffs going through these changes. There are presently three people on the staff who work directly in classrooms, organize workshops and school conferences, and spot people who have particular skills within such areas as evaluation, Piaget theory, group dynamics, math, dance, and science. The staff makes television tapes of visiting consultants so that a record can be kept for the use of teachers and administrators.

The background and personalities of the staff are important in changes of this type. One is a former art director, one an art teacher, one a kindergarten teacher who was trained in the Bank Street Follow-Through model. Each is concerned about changing elementary education and developing a situation in which change itself can be examined. The importance of such a team is that it can serve as a model for a shift in the role of specialists in art, music, reading, library, physical education, guidance. There is certainly a leadership component built into such a team. What if, for example, specialists could meet with consultants for short but consistent periods of time over a period of a year? They could be exposed to the most recent and meaningful ideas in psychology, group dynamics, psychomotor development, perception, and planning. In other words, they could be retrained as a leadership team. They would then be prepared to work with classroom teachers in a new way; by pooling their talents and training they could help teachers make connections between learning theory and day-to-day activities with children.

In the classrooms, the Learning Dimensions Program staff tries to respond as quickly as possible to the requests and questions of teachers. The staff members

5–8. One nine-year-old draws the other's silhouette—a way of finding out about himself and someone else.

introduce ideas into the classrooms. For instance, they might work together in the same room, providing the nucleus for three different activity centers such as visual arts, math (usually Nuffield-based), and poetry writing. Children can then choose which center they prefer. The teacher is asked to remain free to wander among the groups, question, listen, watch, see how the children are responding and how structured and well-planned a center must be. For instance, in the math center children might be measuring the perimeters of objects of different size, without rulers, and then making bar graphs to show the differences. This is one way of seeing patterns and relationships. The activity involves choosing, comparing, recording. It involves thinking. In the visual-arts center, children might be finishing the painting of some papier-mâché puppets that they will use later in developing a

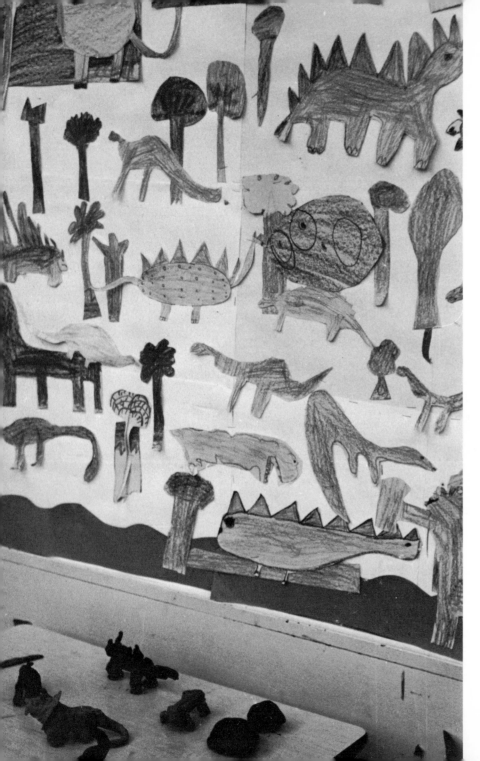

play of their own. They constantly question each other, laugh, and talk as their puppets begin to take on character. In the poetry center, children might be listing as many nonsense words as they can that sound like the words they have been given, or they might be making analogies, finding things inside the room that are like some things outside the room. Each activity deals with patterns, discourse, decisions, imagery, comparisons of shapes, colors, and sounds. Once a teacher begins to see his own students in this type of situation, it is easier to believe that not only do children not have to be strictly controlled every minute but that, given some leeway in open-ended structuring, they can be productive, creative, and self-controlled.

Reading usually takes place between one child and the teacher or an aide. Other children work in small groups or alone with several different activities, perhaps each related in some way to reading. The adult might question the child about things that have happened to him, about events that seem important to him. From the conversation comes a word or sentence or story written by the child or dictated to the teacher. Children seldom forget what they tell or write, and phonics skills are slipped in and developed with each child as the need reveals itself. This approach to beginning reading calls for sensitivity on the teacher's part in terms of really listening to the child. That act in itself often makes the difference in a child's will to read. Writing and reading are interwoven into everything else a child does. Drawing is seen as another way of symbolizing an idea, so it is often offered as an alternative way for the child to record his thoughts. Advanced readers are encouraged to choose their own books in the school or class library, list the words they do not know, talk with an adult about the

5–9. A prehistoric animal mural and clay objects by a third-grade class. The learning process combined discussion, research, drawing, modeling, sorting, and arranging into a pleasing pattern.

contents of the book. The basic approach is that advocated by Sylvia Ashton-Warner in *Teacher*.

Teachers soon see the usefulness of children working with water tables, sand, mirrors, scales, blocks, puzzles, games, *if* the focus for their use is on learning. Fewer and fewer teachers see these activities as just play.

One of the outgrowths of the activity-centered approach is reporting the day-to-day progress of each child to parents. How can anyone be graded by numbers or letters? Who understands them? Are not grades based on a curricular hierarchy, where everyone does or does not come to the same point of the same subject at the same time? Is not failure always built into such a system? Some ways of dealing with reporting are having children keep their own logs each day, writing reports to parents, holding conferences with parents, keeping teachers' logs of each day's happenings. For example, an eleven-year-old wrote in her log:

When we was down to music Miss Barnes played "Soul Power." Then we was dancing and Lisa and Wanda and Rochelle. She shouted to us to do 1–2–3 when we played on the sticks. She told us how to do "Jack-Be-Nimble." Then we did. Then it was time to dance. Me and Lisa and Wanda was trying to do a step. Miss Barnes play the piano. Then we followed her with our sticks. Then it was time for lunch.
Too cool for you, Mr. Kern.

Pages from a third-year teacher's log indicate a child's progress over the year:

12/18 Daisy is not writing her work in her reading book. Does not know all her words.
1/6 Daisy has slipped back. Needs to study her words and look at beginning sounds. Does her reading work in her book. Digraphs sh, wh, ch, th. Having trouble with K. Worked on it.
1/12 She read her last story. No problem.

5–10. Kinetic space—children arrange chairs so they can crawl through the empty spaces. This use of the body helps to form a conception of space that is strengthened by the use of clay, paint, constructions, and dance.

1/13 Absent.
1/14 Reading S.R.A. [reading materials]. Read her story.
1/20 Daisy wrote a beautiful story about her friend. Writes in sentences. Interesting story. Punctuation good. Spelling good. Good manuscript writing. Writing first name nicely in cursive.
2/16 Wrote a story about a picture she drew. Couldn't find her book. Told her to look at home.
5/5 Daisy is working on S.R.A. She can read short passages and comprehend. She is writing good stories. Needs to work on sounding out, rhyming words, and beginning sounds.

Conferences with parents explain why classrooms are organized differently from the ones they went to. The conferences also let teachers know whether parents see differences in their children's behavior at home, whether they write more, read more, want to go to school. Teachers have found that parents are overjoyed at teachers who believe their children can and will succeed. They realize "something different" is happening when, out of a huge family, suddenly a child comes home from school reading, wanting to go back the next day, enthusiastic about his teacher. While the child does not often speak of love, we hope it is mainly because of it that he likes school.

The most important aspect of implementing a program aimed at basic changes in elementary (and secondary) education is the cooperation of the superintendent, district superintendent, and curriculum coordinator and, most important, active and visible support from the principal. It can safely be said that no program can exist or grow in a healthy, positive way without this. A principal has to have the courage to admit that traditional methods and values might not be working for the benefit of most of the children. This is the first impulse toward change. A principal must be willing to reevaluate, grow with the staff, question, be questioned, give up a parent-image role with a staff of teaching adults. A staff must be able to make its own decisions for growth by taking responsi-

bility, helping develop policy, questioning traditional practices, implementing new ones, working together. The principal must be almost immediately responsive to the staff in terms of decisionmaking. Putting off decisions causes loss of credibility and delays answers to questions that arise, so that little energy or insight is left for making either major or minor changes. The principal must make some kind of basic commitment to a program devoted to changing the whole look of learning in a school. If the commitment is to be actualized, more faculty meetings are devoted to discussion and planning by the staff rather than to insignificant administrative matters. More work is done by the principal in each classroom, especially if a

5–11. The movement of the human body has analogies in the use of many art materials. These ten- and eleven-year-olds explore movement that can later be compared to the woven patterns on the wall behind them.

5–12. Children film each other as part of a movie on their city. Using a camera (or a sketch pad) forces one to concentrate more directly upon the environment.

specific subject-matter skill can be offered. More support is given, in terms of both failures and successes, to the staff and the children. More encouragement is given for ideas; more help is offered to implement them. More human resources are called on, both outside the school and even outside the school system, to support the kinds of change that deal with a staff's view of the world. It is evident that a principal cannot do this alone. The Learning Dimensions staff provides some of the support that may be needed for such changes.

For such a program to flourish, the tone of a school must be exciting, oriented to change, questioning, tolerant of various stages and styles of each person's development. But a principal and a program staff must also know that they are supported by the administrators of the school system. A program such as this must start with approval from the top. Otherwise it will end up as a series of unrelated single classroom models, used only by teachers who have the personal strength to withstand being different.

The Learning Dimensions Program is an approach that deals with total staff involvement in the total learning process, working together at all levels to change the face of education so that our children's minds and hearts will not die.

RELATED READINGS

Ashton-Warner, Sylvia. *Teacher*. New York: Simon & Schuster, 1963.

Brearley, Molly, and Elizabeth Hitchfield. *A Guide to Reading Piaget*. New York: Schocken, 1969.

Brown, Mary, and Norman Precious. *The Integrated Day in the Primary School*. New York: Agathon, n.d.

Deutsch, Albert. *The Disadvantaged Child*. New York: Basic Books, 1968.

Dewey, John. *Art as Experience*. New York: Putnam, 1959.

Erickson, Eric. *Childhood and Society*. New York: Norton, 1964.

Furth, Hans G. *Piaget for Teachers*. Englewood Cliffs: Prentice-Hall, 1970.

Holt, John. *How Children Fail*. New York: Pitman, 1964.

Marshall, Sybil M. *An Experiment in Education*. Cambridge: Cambridge University Press, 1963.

Moffett, James. *Teaching the Universe of Discourse*. Boston: Houghton Mifflin, 1968.

Montessori, Maria. *The Secret of Childhood*. Notre Dame, Ind.: Fides Press, 1966.

Sealey, Leonard G., and Vivian Gibbon. *Communication and Learning*. Oxford: Basil Blackford, 1962.

Silberman, Charles E. *Crisis in the Classroom*. New York: Random House, 1970.

VISUAL ART IN INTERDISCIPLINARY LEARNING

Don L. Brigham

If we can accept that learning is change of consciousness in a person expressed through his behavior, then we can recognize that learning is a natural expression of the activities of human life. Learning is always going on if human beings are actively experiencing. Through probing and comparing of sensory and structural aspects among objective things and happenings, through constructive shaping of mental imagery as a consequence of sensory probing, and through associative reflection upon the meanings and relationships of these cognitive images, the human learner fashions comprehensions of his sense of reality in the world. Through communicative stating, exhibiting, gesturing, demonstrating, explaining, or performing, he articulates his coping competences in that world of reality. His learning is always creative and self-expressive in that *his* cognitive structuring is formative within him as a consequence of *his* activities of experiencing and *his* patterns and modalities of responding and communicating.

Nonverbal learning is sensory and perceptual activity leading to the symbolic representation of experiences in the forms of mental and kinesthetic images. This creative formation of sensuous imagery is a prerequisite for more abstract mental conceptualization and intellectual contemplation. There is an essential connection between visual, aural, tactile, and kinetic imaging with the eyes, ears, hands, and body and the development of personal symbolism to which the learner can attach abstractions of words and numbers. The visual artist, when he is functioning authentically through expressive structuring of experience into imagery, is an exemplary nonverbal learner.

The outstanding and limiting characteristic of most school situations is the isolation of the sensory and perceptual nature of the learner from the reality of the contents that are expected to be learned. The lock-step rigidity of many school environments obstructs learning of the dynamic and ever changing nature of organic reality; abstract terminology and prescribed formulas for interpreting and reporting textbook subjects separate the child from concrete awareness of the realities to which the subjects refer; nonsensuous print, chalk, and boards and recitation and lecture media convey no sense of either the natural world or contemporary electronic media environments, and a social hierarchy that posits all knowledge and authority in the teacher and all knowledge-seeking and dependence in the pupil denies the self-realization and self-responsibility for learning through orderly release of the innate need to know and master life that is the birthright and obligation of individuals in democratic society.

Every human being desires learning. People, arts, sciences, nature, histories, technologies, languages, and cultural modes of behavior are a confusing, disturbing, and frustrating blur to a person who is restrained from learning. The inhibition and repression of natural avenues to learning through institutionalized "subject learning" systems in our schools is an inhumane distortion of their democratic purpose. It is the greatest irony and disappointment to realize that "art," that most humane avenue of self-world realization, has also become a standardized subject-system imparting conventions of craft, media, form, and design, representation or nonobjectivity, and standards of taste or judgment in many schools under the presumption of "creative" education.

When I entered late in the 1950s into public school art teaching at the secondary level, I discovered that my art room and "creative studio art" assignments were only superficially related to the art knowledge that I had acquired in my education as an artist. Whereas I had learned through experience of the profoundly transforming significance of the perceptual processes of creative art activity, I discovered that my peers and my pupils—who, I felt, had been preconditioned to a narrow view of art—could conceive of art only in terms of oil paintings, watercolors, mobiles, abstracts, or other conventionalized category of technique and form. No one in my experience then perceived of art as having any direct bearing upon the nature of learning. Learning was presumed to be the province of "academic subjects" and "study skills," whereas the art period was a release from such concerns.

I felt that efforts to transmit an authentic understanding of art through school courses generally labeled humanities, art history, or art appreciation usually failed to impart the experiential processes essential to esthetic

6–1. Sixth-grade boys learn to compare and contrast in a reading skills program. After collecting similar and contrasting words, they collect similar and contrasting sensory objects. Photos in this article by Stephen Price, 10th Grade.

knowing. Such studies are usually factual, literal, analytical, and discursively linear. Esthetic cognition, however, is sensuously presentational in terms of colors, planes, textures, and shapes, and it is metaphoric or analogical rather than literal. It is simultaneous in terms of a graspable configuration rather than strung-out as a story line, synthesizing or whole-forming rather than atomistic. "Humanities" and "art history" generally communicate study disciplines of verbal literacy, linear conceptualization, and analytical categorization rather than comprehension of the visual-perceptual language of art.

After several years of teaching at the secondary level and upon appointment as supervisor of art education in the Attleboro, Massachusetts, school system, I decided to engage the staff of art teachers in generating a coherent curriculum design for art. During our first year we examined existing curricula, philosophies, and objectives in art education and theories of the nature of esthetic experience. We also referred to general theories and practices of curriculum design. Most art curricula were, we felt, merely outlines of conventionalized art media and techniques. Some attention had been given in art curriculum guides to "design elements and principles," but these seemed warmed-over concepts of the 1940s and they were tame and sterile in relation to the vigorous spirit of antiformalism that had been generated by abstract expressionism, "assemblages," "happenings," and pop art. We found little curricular attention in art education to planning for sequential and incremental development of perceptual and media structuring competences or of esthetic awareness in general. "Creativity" seemed a magic word, like "appreciation," interspersed regularly as a moral imperative but rarely specifically defined. It appeared to mean "self-expression" and to be a directive against the intrusion of teaching.

In our search for curriculum models, we also examined publications of the "education of vision" movement

6–2. The analogy hunt—a boy searches for things of comparable perceptual qualities. This switching of contexts forces him to observe more sharply, to make inferences beyond the immediate object under consideration.

whose prominent practitioners and theorists were Rudolf Arnheim, Bartlett Hayes (who had established at Phillips-Andover Academy the Visual Communications Center for explorations in visual perceptual interdisciplinary learning), and Gyorgy Kepes (who developed the visual-design course at M.I.T.). In studying the ideas of these men, we discovered a clear articulation of the nature of contemporary experience and knowledge as structured and communicated through nonverbal media. The experiential perceptual organizing skills of artistic insight and intuitive whole-forming had been applied by these men (and

particularly by Kepes) to the task of discovering coherent relationships among the chaotic languages of twentieth-century communications media, technologies, and arts and the so-called knowledge explosion. The education-of-vision spokesmen thus provided a basis for the development of a curriculum and a method for art education in the public schools of Attleboro.

After development of a curricular plan focused upon the perceptual experiencing skills of art, we proposed a pilot demonstration through Saturday classes composed of a representative sample of pupils drawn from the public and parochial schools of the community, at the middle and junior high levels. In pilot "studio-classrooms," modern educational audio-visual resources, along with reproductions from the world's art heritage as well as contemporary art and science, were to be integrated with traditional school art media and methods. Classes were to be prepared and conducted by interdisciplinary teams of teachers. The proposal was submitted for consideration for federal funding under Title III (Projects to Advance Creativity in Education) of the Elementary and Secondary Education Act.

Support for our plan, facilitated by the U. S. Office of Education and the Massachusetts Department of Education, came early in 1967. Teachers of every level of instruction and many subject and skill specializations joined with art teachers in developmental workshops. Later, through random-sampling methods, a cross-section of pupils was invited from the fifth through the tenth grades of all schools of the community. Of those who wished to participate, twenty-five were enrolled in each of the four pilot classes for the 1967–68 school year with four cross-subject teachers assigned to design learning experiences for each class. During 1968–69, emphasis was given to the

6–3. In "feelies" and "mystery boxes," children translate a tactual or olfactory experience into a visual image. The cylindrical box is a "zoatrope" which, when rotated, produces a "movie" image of a sequence of drawings.

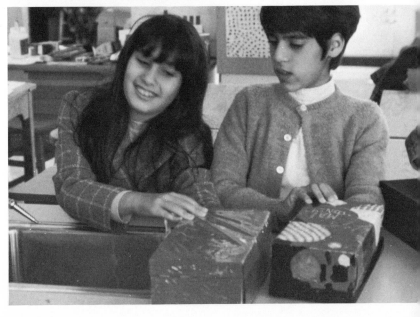

improvement of fifth-grade visual learning, and seventy ten-year-old pupils, representative of their peer population, were enrolled with thirty-five veterans of the first year of pilot classes.

During midweek afternoon workshops, teacher teams examined the visual arts for their characteristic forms and modes of expression, and they experienced, often with the assistance of a visiting consultant artist or visual-design and communications specialist, the perceptual modes of art comprehension and the creative processes for forming communicative art objects of past and present visual artists throughout the world. By analogous perception—that is, by comparison of structural and other sensory qualities—they connected patterns of visual composition that they felt were appropriate to concepts and generalizations of school-subject contents to the design structures and structuring processes that they perceived in the visual arts. This meant, of course, that they had to visualize and construct ideas and processes of relationship within and among the subjects of school learning where verbal-literal and numerical-computational modalities had previously dominated their learning experiences. Visual-arts structures came to provide objective, concrete references for the abstract concepts of many school subjects. The teachers also experienced the comparison of the creative and formative processes of artists with the organic form-evolving processes of nature.

Teachers might design a learning experience as follows.

1. A generalization is established as the conceptual objective to be developed through learning activities, such as "Organic processes of change of form are similar in nature and art; organic transformation is the expression of life forces interacting with and adjusting to environmental forces."

2. An appropriate learning environment is specified: projection screening facilities, tackboard for large pictures, camera and "visualmaker" kit (slide-making), magazine and book picture sources, overhead projectors, facilities for structuring, atmosphere conducive of free exploration and improvisation.

3. Activities are specified to transmit the generalization nonverbally: viewing filmloop projections of plant and flower growth expressed through time-lapse photography; viewing 16 mm. movies and filmstrips following the form-evolving processes of sculptors such as Henry Moore; viewing sequences showing metamorphic processes such as from evolution from an egg, earth-science transformations from the rise of mountains through subsequent reduction through erosion; viewing 16 mm. movies of a potter evolving a form through wheel-throwing; viewing slides and mounted pictures illustrating the principle of "form follows function" such as in the organic architectures of Frank Lloyd Wright, medieval towns, and forms of animals, reptiles, and crustaceans that are adapted to their environmental conditions. Seated in row formation, the learners sequentially modify a line drawing started with a single line by a person in the first row who had a whole object in his mind's eye but drew only a segment. Each learner, as he receives the drawing, quietly adds a line to "pull" the drawing in the direction of the thing he imagines in the uncompleted drawing. The last learner of the row completes the drawing and asks the first, and each learner sequentially, to state what he saw at his stage in the process. All these progressive transformations are then compared with the drawing of the last person in the row. These learners then build slab pots shaping the final forms through force-counterforce by poking outward from within with fists and wood shapes or paperwads and by paddling, beating, and poking inwardly with their hands and paddles. Given the problem of designing a carrier constructed of Bristol board and staples and then enclosing a medium-weight egg within it, the learners then look at all the carrier constructions and rate them as more or less beautiful or pleasing as forms. The constructions are each dropped

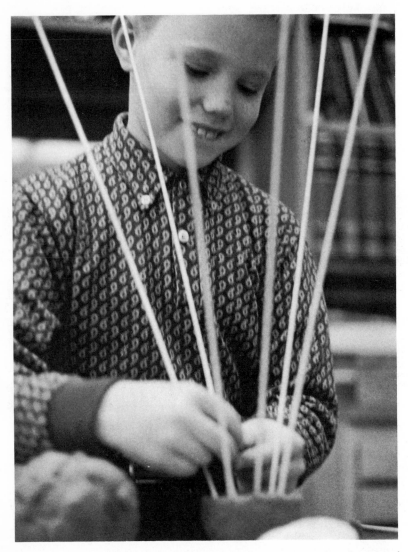

6–4. After creating their own expressions based on word experiences—this boy is "shaping a yell"—fifth graders responded to comparable works of art through slide presentations in their Visual Learning Center.

6–5. Edvard Munch, *The Shriek*.

from a six-foot height onto a hard floor covered with newspapers. The carriers that successfully protect the egg from breaking are exhibited along with a statement of the weight of the construction materials.

4. Evaluations are established to determine whether the learners have acquired conceptualizations (in their own terms) equivalent to the original generalization of the teacher. Examples might be: pupils are able to express verbally or through pantomime a sequence of force-counterforce developments in their creation of the slab pot and an equivalent sequence they perceived in one of the films shown earlier in this learning activity. They limit their expressions to the formative developments in the filmed evolution that they feel also happened in the pottery evolution. They are able to state how, in the sequential line-drawing experience, each stage might be likened to a changing environmental condition in the evolution of a biological form. Finally, they are able to state a meaning for the egg-carrier experience that includes their explanation of why data about weight of construction materials affected their opinions about relative beauty or form. The successful carriers were all associated together in the final exhibition; each learner then chooses one example of the organic architecture of Wright or of a medieval town that he believes exhibits the idea shown by the egg-carrier experience.

This example of interdisciplinary arts-in-learning design demonstrates inductive or discovery learning —through multisensory and manipulative activities combined with verbal and nonverbal improvisatory problem-solving—of a visual-arts concept-centered curriculum. During 1969, the final year of U. S. Government funding of the project, the staff formulated a curriculum guide-book of thirty-two sections, each containing a variety of visual representations that included pictures of pilot pupils engaged in learning from pictures and diagrams representing objects, pictures of events, and pictures of

6–6. After seeing slide reproductions of French Rococo art, children looked for comparable "wiggly," "frilly," "fancy," and "dizzy" things in their Visual Learning Center.

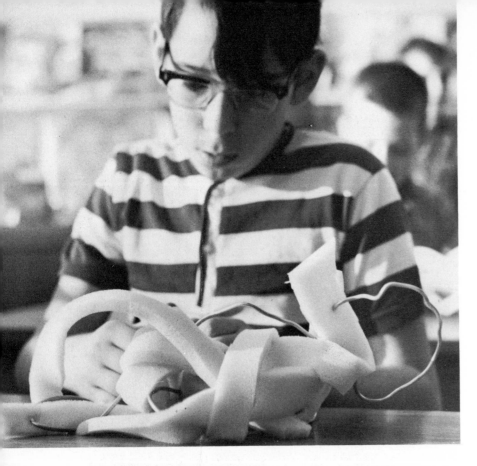

6–7. A boy gives shape to his perception of French Rococo using contemporary materials. In this activity, there can be no form without some prior base of feeling.

the principles of the arts and sciences. This guide illustrates the meaning of a verbally stated visual-arts concept that headlines each section. A sample of these arts-in-learning conceptual statements follows:

A point locates a position in time or space.
Line forms our visual ideas of sequence, extension, and continuum through time and space.
Visual gradation is the gradual increase or decrease in size, weight, intensity, and brightness of elements in space and time.

Perceptual rhythm is regular, positive, and negative.
Closure: Perceptual completion of an unclosed array of visual elements resolves fragmentary sensations into whole forms.
Figure and ground differentiation: Perceptual definition depends on separation of shapes from a background.
A process is a continuum of transactions and transformations.
Growth processes having spiral form reflect forces striving for equilibrium.
Visual abstraction is a perceptual process of drawing out a pattern of main features from a complex field.
Visual analogies: We may discover connections among diverse things by perceiving their common characteristics of visual form.
Gross-subject communication: Basic principles of different subject-fields may be unified in single visual patterns.

Each conceptual statement of the arts-in-learning curricular structure was carefully generalized to apply to truths or principles in several subject areas as well as in the visual arts. It was presumed that teams of teachers representing different subjects might proceed from the generalizations to the design of inductive multisensory problem-solving experiences that incorporate contents and skills of their several specializations. Some representative experiences are described below.

Sensory crossovers: a sensory impact of one modality may be perceptually experienced through another. "Mystery boxes" have been arranged along a counter. Learners reach through hand holes at either end to explore two things that they have not seen but discover are alike in quality though different in fact (a fuzzy stuffed animal might have been placed inside, along with a wad of steel wool). Teachers have represented sensory qualities with textural drawings and with words on separate cards. Each pupil selects one card that, through visual or verbal symbolization, best represents the sensory quality that each

6–8. Seventh- and eighth-graders explore the paths of falling leaves, grasses, feathers, and paper forms. They then represent these dynamic patterns in both two-dimensional and three-dimensional media.

of the divergent objects shares in common. Placing his card within a "ballot box," he will learn later how his choice compares with the choices of his peers in the case of each "mystery box." In later discussions, learners may consider other environmental experiences in which they have "seen" a texture, "touched" a sound, or "heard" a color, or they may consider sensory-verbal crossovers in which words evoke sensations or sensations evoke verbal expressions. (Film documents show pilot-class pupils

forming original three-dimensional constructions and assemblages expressive of their responses to stimulus words such as "bumpy," "wiggly," "flap," and "yell.") They may also make observations about the different ways in which people symbolize and communicate their perceptions.

Dynamic whole: harmony is a coherent interrelationship of complementary parts integrated into a whole form. Asked, "What is the opposite of black?" seventh-graders respond "white." Asked "What happens if you mix black

6–9. A transparent box provides five points of view, which these fifth-graders can represent on the cellophane surfaces with felt markers. Later, they superimpose their images to form one integrated expression of their several points of view and compare their works with cubist paintings.

and white paint of equal amounts?" they respond (after paint explorations) "You get gray." "What is the opposite of yellow?" "Don't know." "If grayness results from mixing white and black paint equally, mix paint to find what color of equal strength blends with yellow into grayness." Discovering that violet makes the best gray with yellow, the learners then seek the opposite of orange. Comparing these color-mixing experiences with their ideas of what happens when two opposite forces of equal strength encounter each other, they develop an awareness of neutralization and balance of power. The learners construct models of their concepts of dynamic balance by using

elastic bands or balance weights. Their teachers introduce the word "complementary" and show its application to a color wheel. The learners discover that their models exhibit a principle of integration through complementary balance. Finally, the seventh-graders react to slide projections of paintings by Vincent van Gogh that exemplify harmony through balance of complementary hues.

Spirals: systems having spiral form reflect dynamic forces striving for equilibrium. Middle-school learners study the paths of falling seeds, leaves, and folded paper. They drop these from stepladders, watching for the pattern of the falling. After marking structurally prominent points on the leaves, for example, they watch for the line of descent of each point. They make drawings of these lines of falling points with felt-tipped pens. Then they build models of these linear configurations, representing the lines with wire suspended within a tall frame constructed of styrofoam blocks at top and bottom separated by long dowel rods. Colored gumdrops along the wires mark the relative positions of leaf points during the fall. Discovering that helical and other spiral patterns are characteristic of falling paths of leaves and seeds, they go to pictorial encyclopedias in the school's library to inquire into spiral structures, their presence in phenomena such as hurricanes, whirlpools, plant growth, and helicopters and the structural principles relative to forces and counterforces that account for the evolution of the form. They write a statement of the functions of spirals and exhibit this report with their leaf-fall models.

Closure: things and events perceived in parts may be combined into a whole concept. Fifth-graders examine visually an arrangement of objects set within a transparent box measuring eighteen inches on each side or an open frame covered with cellophane. Using felt-tipped markers, they draw on the four sides and top of the cellophane box the prominent outlines pereceived from their separate viewpoints. They also use textural graphics to show the

6–10. Modern learning media (slide, film and overhead projections) are resources in the Visual Learning Center. These seventh-graders are translating their impressions of a two-dimensional work of art into a three-dimensional structure of straws.

various surface qualities of the enclosed objects. They cut the shapes of some of their outline drawings from opaque papers and other colored cellophanes and fix these with white glue on some faces of the box. They also apply strings and yarns to some of the lines of their drawings. Then they remove the five sides and arrange them in a single composite view through overlay of the transparent sheets. Framing their composition, they hang it before a window or other light source. Then a series of cubist paintings is shown by their teachers and the learners select the one that they feel is most like their composite representation. They are then engaged in a discussion of points of view in, for instance, a trial wherein the perceptions of various witnesses must be composed by judge and jurors who seek a true description, or they consider how the same event may be represented differently by opposing teams or warring nations.

These examples of multisensory inductive learning experiences show how teams of teachers develop a series of physical media activities and thought-provoking questions or problems that gradually structure the learners in the direction of the visual interdisciplinary concept, which, agreed upon as the basis for a learning-process design, prompted the teachers to initiate the activity. Interdisciplinary conceptual team-teaching is gradually being implemented throughout the grades of the Attleboro public schools. Bringing the various concepts and thinking skills of their subject specializations to interdisciplinary planning sessions, teachers select those that are shared in common among subjects and that can be visually expressed. Sometimes, to clarify their thinking, they fashion a two- or three-dimensional model of the conceptual structure isolated for consideration. A collage representing a rhythmic sequence might articulate a relationship in music, math, art, physical education, and reading. Music, art, or reading resource teachers then bring their sensory-composing and verbal-structuring competences to larger teams of subject and homeroom teachers. Teaming tends to pool the knowledge and talent of teaching personnel and, through flexible "block unit timing," teachers who previously were locked into rooms and periods now manage large groups of pupils simultaneously, conserving time before and after a comprehensive learning activity for cooperative planning and for evaluation.

Teachers in an interdisciplinary concept-discovery program become catalytic agents of learning. They *cause* learning much as an imaginative, creative scientist manipulates an interaction in the laboratory or as an artist trying color and textural relationships pursues the resonant harmony he perceives in his mind's eye. Each works a hunch. The teachers have a learning hypothesis in mind for a curricular objective: "If we conduct the children along this path of encounters with these sensory materials and these symbols and pictures, it is our intuition (our visualized expectation) that many of the children will discover this relationship or principle or this sensory integration, which is the conceptual-learning objective that we hope to achieve." These creative teachers prepare materials in an appropriate environment, or they prepare a learning-activity package of multimedia components for individuals or small groups, designed to provoke the experiential happening that can cause the hoped-for conceptual structuring in the minds of learners. During the happening, they add a stimulus such as a new color or art medium, a slide reproduction, another light source, book information, a rhythmic sequence of sounds. When the child sees the consequences of his transactional encountering, he has learned! And he experiences the esthetic satisfactions of the harmony or sense of beauty that is the reward of a good solution, a perceived relationship and the resolution of chaotic stimuli, incongruence, or dilemma. Learning, in the creative conceptual-discovery school, becomes an esthetic activity and learners and teachers become, in the best sense, *artists.*

REDEFINING THE
NATURE OF ART:
ART FOR SELF AWARENESS

There have been and are now occurring many changes of direction in art education, yet if one were to visit most programs now in operation, a view of art would emerge that would in reality reflect a small segment of the broad world of the professional artist. By and large, art teachers still cling to the model of the artist, probably because their own training has been designed to reinforce the idea that the behavior of painters, printmakers, craftsmen, and sculptors still provides the proper basis for the training of teachers. In its way, this is not an inappropriate argument except that it is not completely responsive to other models that have entered the field. Manuel Barkan was aware of this when he wrote,

> Art education is in the midst of far-reaching changes in ideology and practice. Modifications in conceptions of curriculum and the teaching of art are beginning to show their effects in the elementary and secondary schools. Beliefs and assumptions about objectives, content, and methods of teaching are being reexamined. While some of these beliefs are being reaffirmed, refined, and

sharpened, others are being discarded. Transformations are in process, new insights emerging, new perspectives being explored, and new practices developing.[1]

Still, one wonders if even Barkan was fully aware of the import of his own remarks. Barkan's ideas, as stated in the report of the Commission on Art Education and in *Guidelines for Art Instruction Through TV for the Elementary Schools* and *Guidelines: Curriculum Development for Aesthetic Education,*[2] still use the artistic object as the primary focus of attention; its production, its history, and the transaction between object and viewer. His instructional tasks, which derive from the art object, suggest a wide battery of experiences ranging from the verbal to the manipulative, many of them fresh and imaginative in their reflection of the new research and thinking of artists, critics, and learning theorists. The fact remains, however, that the visual arts have either gone beyond the object or that the nature of the art object itself has undergone radical transformation. The eagerness with which certain artists have embraced the skills of the technologist and the group therapist and the zeal to cut across established formal categories of the past are but a few symptoms of the shift in the artist's own conception of his product. Nor is this a particularly new phenomenon, when one recalls Duchamp's questioning of such basic assumptions as the primacy of vision as the basis of art. Or consider for a moment the following

paragraph, describing the philosophy of the California Institute of the Arts:

> Never mind that the form is unnameable. What is there that was never before? And what are we to make of it, if anything at all? The questions will not be turned aside, nor what comes of them dismissed.... In that uncatalogued no-man's land between the collage and the Happening, divisions between painting and sculpture are dissolving into history. Some artists, defying the pressures of the modern, will want to reclaim the distinction from the vanishing point. They will need every skill and insight that history can offer. Others, absolutely committed to the present, may want to work with 254 pieces of grey felt, or with fiberglass and epoxy, or with resin dye in acrylic lacquer on a plexiglass cylinder of distilled water.[3]

Consider also the situation that exists at the Massachusetts Institute of Technology, where a laboratory has been created for artists and scientists to work in consort in order to create the "unnameable." If sound synchronizers, earth-moving equipment, circuitry, and the human form itself were to be moved into the school art program, if art teachers were asked to create experiences that could never be exhibited, if process, ideas, and problem-solving were deprived of manageable, even observable, form, would it still be art in the terms of the public schools? If the schools could accept such activity as art, how would such experiences fit in with Barkan's assumptions about the nature of art? Let us take one example: if a teacher's concern is heightened critical awareness functioning with a historical context, how will that teacher handle an intermedia production involving a dozen people moving in a prescribed manner around a laser-controlled pattern to the accompaniment of feedback to a set of loudspeakers? What can the past

[1] Jerome J. Hausman (ed.), *Report of the Commission on Art Education* (Washington, D.C., National Art Education Association, 1965), p. 69.

[2] *Guidelines for Art Instruction Through TV for the Elementary Schools* (Bloomington, Ind.: National Center for School and College Television, 1967), and *Guidelines: Curriculum Development for Aesthetic Education* (St. Ann, Mo.: Aesthetic Education Curriculum Program Center, Central Midwestern Regional Educational Laboratory, Inc., and U. S. O. E., 1970).

[3] Bulletin of California Institute of the Arts, Fall 1969, Sheet 2.

teach us, how can estheticians prepare us to maintain a critical stance in light of such a curriculum? Indeed, is criticism relevant at all under such circumstances?

Don Seiden's account of art as it operates in a "school without walls" is difficult to classify, but then it is not always possible to expect all programs to fit into convenient categories. Seiden's program suggests an effective liaison with the art school and has implications for the training of teachers. His study also bears comparison with Lowry Burgess', for both men are interested in art as it relates to the students' total sensory experience. Both Seiden and Burgess are trying to get at the roots of the creative experience. Their programs rest on the premise that too often the visual experiences of adolescents are superficial and do not truly reflect a deeper consciousness because, for one reason or another, that layer of awareness has not been tapped. They seem to be saying that if the sources of art seem to lie in myths, dreams, and fantasies (Burgess) or in sensory, emotional, and physical aspects of self (Seiden) then by all means, let us concern ourselves with developing these possibilities rather than with their products, for it is in studying the life of the emotions that art can have its deepest meaning for the adolescent. Rita DeLisi joins the two at this point with her handling of sensory-spatial-social awareness for the elementary student.

DeLisi's report is also a case in point regarding the impact that lies apart from any program—that is, in the magnetism of the teacher. DeLisi has for some time enjoyed a strong personal following among many who have been associated with her in the classroom. It is,

therefore, difficult to separate the effectiveness of her program from her own warm personal energy. A teacher's style and its effect on learning often exists in a world away from the more predictable realm of program planning. In an article written for *Art Education*, Betty Tissinger stated the case for the art teacher rather than the artist, critic, or historian as a model for art education. In discussing such "master teachers" as Sybil Marshall and E. S. Richardson, Tissinger concluded,

> "They are highly skilled in human communication and understanding as well as in their subject matter. In addition to this, in much the manner of the child, they seem to have kept something of the wonder and magic of seeing things new and afresh day after day."[4]

Such attributes would certainly apply not only to Rita DeLisi but to Lowry Burgess, Don Seiden, and the others in this book.

In any case, it is well to bear in mind the teacher variable in considering the success or failure of any agenda. Neither Burgess' or DeLisi's programs could have succeeded without the freedom of the "open-school environments," and neither Madeja's system of packages nor Eisner's many support materials could have existed without the generous financial support given them. When studying the uniqueness of its shape and content, then, the *setting* of an art program must be considered as well as the nature of the teacher.

[4] Betty Tissinger, "In Search of a Model," *Art Education*, 24 (April 1971), 27.

THE HIDDEN LANDSCAPE: ART FOR THE OPEN SCHOOL

Lowry Burgess

I have been asked to describe and explain what I was trying to do in my teaching at the Murray Road School (an annex of Newton High School) when it was started in the fall of 1967. After giving some brief background to the Murray Road School, I will provide a very simple outline of the structure of the course, with examples of exercises from each category of the outline, and then some comments about various methods. I will also include comments of the students and excerpts from my daily notebook, as well as some fairly tortuous thoughts attendant on this work.

In August 1967, Al Hurwitz, Coordinator of Arts for the Newton Public Schools, and I met to discuss various projects. We talked about what we were both doing and he told me about a new experimental school, the Murray Road School, in Newton, Massachusetts, which was to open in the fall. The school was to be run by teachers in committee and students from the Newton high schools who volunteered to attend. Al asked me if I would be interested in working on the project, directing an art program, and I said I would.

The school was to be small. Altogether, 110 students from Newton High School signed up and at least two-thirds of the school population expressed a strong interest in the arts. My own course differed from others in its emphasis upon the various avenues by which a student could look more intensely at himself and his environment and in its concern, in one way or another, with that much abused word "creativity."

That word for me has at least four possible directions implied within it. First, there is creative action toward an object, form, or goal that has specific criteria placed upon it. Second, creativity allows for disposition toward certain possibilities that can provide a range of action or understanding that can be social, perceptual, psychological, cultural, existential, or spiritual. Third, truly creative activity can destroy the vast complexity of masks that we impose and that are imposed upon us to separate us from direct intuitive experience. And, fourth, creativity can lead us toward the perusal of ever deeper images of archetypal dimension, so that existence on a more profound level becomes accessible to the student. (Hence our concern with memory, myth, time, fantasy, and dreams.) Add to these directions of creativity a desire for broader perceptual toleration and depth, add to that a concern for an unfolding of gentleness, intimacy, delight, and awe, and you have some of the hopes I held then and now hold.

7–1. Sensory awareness based upon a fresh investigation of a common material. Students feel clay with their eyes closed to sense its intrinsic qualities.

A group of exercises began to collect around my despair over the self-conscious, doubtful, stereotyped, and unhappy esthetic responses and judgments that I had heard from children and adults. The problem became larger as it began to seem that these garbled responses were tied to other equally constrained responses to nonart problems. I began to ask myself how I might change the basis of such judgments or responses through spontaneous activity rather than through lessons on culture. Thus, this series of apparently disconnected activities, some old and some new, began to develop. These exercises became the

course, which was made up of approximately 140 simple and complex exercises (which I initiated and then participated in), divided into five basic categories. The five categories, with a few sample exercises from each, are:

1. *The Inner Landscape.* Our concerns with memory, dreams, myths, fantasy—the hidden curriculum. (*a*) *Mind pictures.* Have brushes, paint, palettes for mixing. Shut your eyes and clear your mind of active thoughts. Wait for an image to come; do not strive for the images consciously controlled by the mind or the simpler color shapes you

see when you first close your eyes. Sometimes seeing the image will take ten minutes. Be patient. It will come. Paint the image; study the palettes when they are finished. Quietly discuss, observe. (*b*) *Remembering* (the sensory dimensions of memory). Ask students to concentrate on a memory. How are they remembering it? Through what senses? Which dominate? Can they recover lost aspects of sensory impressions? Why do we remember? How does our memory function? Try to remember something through sight, sound, touch, smell, taste. Can they be put together? Students can act out situations; paint or draw them if it seems more rewarding. (*c*) *Self-portrait with another.* Have any drawing or painting materials available. Draw or paint your own image, combining it with the image of another person in such a way that it shows some relationship to the other and how you feel about that person. In working on this problem, you may change or examine your relationship to that person in some way.

2. *Sensory Awareness.* Sensitizing and stimulating the whole sensorium. What are the edges of sensory experience? How do they overlap? (*a*) *Microsounds.* Use anything available. Find various small sounds that cannot be heard further than arm's length. Find small sounds you like or do not like. Put some combination of these sounds together. Devise some way of writing it on paper. Play it for someone. Play the compositions (duets and solos) for another class. (*b*) *Hand games.* Shut your eyes, spread your arms apart, and open your hands. Then *very* slowly bring the two hands together until you think your hands are as close as they can be without touching, If they touch, start again. Do this a number of times and concentrate only on your hands, so that you feel them completely. It is the total movement that is important, not how close you get your hands. (*c*) *Shaking hands and jumping together.* Stand in a circle. Take each other's hands and shake. Keep shaking until a sort of unison develops. Then begin swinging your hands (still holding each other's hands) back and forth until the whole group

7–2. Rolling balls of clay of equal size with two fingers is an exercise in coordination. Students are asked to shift down from large-scale activities to smaller, more intimate tasks.

is swinging in the same rhythm. Swing higher and higher until your arms begin to lift you off the ground. Keep swinging and jumping all together, higher and higher. Then gradually slow down until you stop. It is good to inhale when you jump up and exhale when you go down.

3. *Mapping.* How do you perceive? What are the peculiar contours of your perception? Why do you see what you see? Can you see it differently? This is essentially about how we form concepts about the environment and how that environment can be seen in new ways. (*a*) *Where have you been? not been?* Have maps of your area, 9-by-12-inch acetate sheets, grease pencils, overhead projector. Lay the map down and trace on the acetate the extent of

where you have gone. Put all the acetate maps on top of each other and project the composite image. Are there any holes? Why haven't any of you been to these places? Would you go there? If not, why not? (*b*) *The shapes of your environment.* Have clay, sand, dirt, blocks of different sizes, cardboard, paper. Construct the major features of your surroundings, natural and manmade. In what ways do these things influence your lives? What are some other major influences (light, climate, winds)? This can lead to some interesting field trips. How do manmade forms and activities respond to natural forces? (*c*) *An image of your space.* Have paper, four colors of crayons. Indicate the most important objects in your environment or surroundings. (These can vary: home, school, roads, parks, land, church.) Order the color of the crayons and have each student draw his most important object in the first color. The second most important would be the second color, and so on. After you have done this, compare, discuss, establish categories. Keep the discussion open. Find words to describe what you see. Discourage any comments about technique.

4. *Building and Making.* Concern with nonjudgmental making. (*a*) *Flags, banners, and kites.* Have wooden poles 10 to 12 feet high, paper or cloth, paint, dyes, inks, polyethylene, sewing machine. Begin by making banners, flags, kites. Work very large or small. What kinds of sounds and what types of movements can these things make? Balloons are more difficult. Cut patterns out of the polyethylene (large if possible), double the seam, and sew. Press seam with a warm iron so the plastic curls and melts around the sewing. Fill the balloons with air. (Try helium if it is available.) Have a festival. Have music, bells, colorful clothes, and the like. We did it in the springtime. (*b*) *Making simple toys.* Have the students find their own materials. What kind of toy can you make out of ready

7–3. A flag and kite festival begins as an individual effort and culminates in a shared experience.

materials. Bright and cheerful things that make funny movements are desired. Interesting shapes and distortions should be produced. Perhaps you could design some toys for a kindergarten near by. This gets into aspects of form, shape, and movement without getting dull and formal. There should be much discussion surrounding this activity (*c*) *Silly machines.* Materials are any kind of junk students can find, any motors, cranks, gears, plus glue, paper, wood, plaster, and so on. Ask students if they could design and make a fantastic machine (either individually or as a group), something that moves and does something, no matter how ridiculous or strange. The machines should be colorful and noisy, perhaps very elegant. Have an exhibit or fair. The point is to develop the sense of movement. The students could make a human machine out of everybody in the class.

5. *Enduring Activities.* Building long-term attentiveness and awareness of small changes. (*a*) *Dream journal.* Keep a dream journal (intensely for a period of about two weeks, perhaps over the whole year). The journals need not be seen or discussed unless the students want to. (*b*) *Looking daily at one thing (and noting small changes).* Choose something you will see daily and watch that thing carefully during the whole year, spending a few moments every day to consider it, to note its changes. (*c*) *Scanning for one object or motif over a period of time.* Choose some motif (a color, a sound, a combination of things). Can you keep it in mind and look for it constantly yet *not* actively? Very gradually over a number of months put together a tackboard on one motif that everyone contributes to. Put anything on the board (writings, pictures, objects).

The method in which these exercises were used and can be used could be seen from many different points of view. They could be seen as sequential, as some of the exercises are progressive from simple to complex or from

7–4. Students create a structure from string and cardboard tubes.

7–5. Early stage of building a dome. This activity was preceded by a discussion of the theories of R. Buckminster Fuller.

7–6. Preparing a polyethylene covering for a dome. Inventive, large-scale use of inexpensive materials is a vital part of the course.

simple to complex within a specific area. You might work from any point or exercise that seemed relevant toward many of the other exercises in what is called the web method, or work as I did (what you might call synchronically) in a meaningfully random way. You must realize that an exercise will yield different effects according to what context it is in (what exercise comes before it and what after). Each exercise is relative to the environmental and emotional field around it. Hence, we did many exercises several times with very different results. That is why there is no specific way they should be used and also why they always seem to indicate new directions each time you do them.

The following are some remarks of the students that were recorded by an interviewer in June 1968. The other text is from my notebook.

Student: I don't like to use the word purpose because it makes the whole thing seem like it had a beginning and it was very final. It wasn't very final. The course is over, school is over, but it's very hard to say it's final, because we're all seeing things in a different way to a certain extent. I think that if there were any purpose it was simply to educate in order that we will perceive things completely.

Notebook (October 24): We now have a room full of furniture—tables, chairs, easels, storage units, etc.—all made of heavy cardboard. We took the cardboard

7–7. Groups of students explore a block-stacking problem: what is the tallest tower that can be built with a given number of blocks? Part of the value here lies in the intense concentration required to perform the task.

7–8. Straw structure with blocks. The universal character of many of the activities makes them appropriate for people of all ages. Much of the course involves rediscovering the joy and directness of early childhood experiences in shaping and forming.

furniture out onto the playground today and I asked the students to pull it apart and build something else out of the pieces. They looked somewhat surprised for a second but then began to build rapidly. They built two very large towers, a griffin-type creature, and a long horizontal dragon that extended two-thirds the length of the playground. Some workmen who were putting up a fence on the other side of the school stopped for almost the entire time we were out and just stood watching us very attentively. When we went back inside, we put all the pieces back into their furniture forms.

Student: Another thing that we did that was good was making concerts out of strange things that people would never think of. Then we went upstairs and gave a concert to an English class . . . and I had an idea for an instrument but I couldn't execute it properly, but I guess that wasn't the purpose of this course.

Notebook (March 7): Now that spring is near, I think it would be good to shift our focus from introspective activities to building and making activities. Before class, I divided a large quantity of small cubes into six equal piles. When the students arrived, I divided them into six groups and asked them to see which group could build the tallest tower with the cubes. Some students built in a random fashion, others with definite systems. The tallest tower was built randomly and reached the height of fifty-two cubes. The students were very absorbed and determined. After they had worked with the blocks, I asked them to shift to using straws and pins. This was equally exciting and diverse, although much more difficult. Five or six students stayed an hour working on straw structures.

Student: I think using all the materials was interesting. When we went outside, I was much more abandoned than I was inside. Maybe it's just being outside that did it.

Notebook (November 7): I began class today by asking a student to tell me how to get to her house. I wrote her directions on the board. After I wrote them down, the class discussed the kinds of directions she had given.

We came to the conclusion that she gave me different kinds of clues at regular intervals. I asked her if she could direct me by a compass, for she had given me clues of right and left, not north and south. Another category she gave was landmarks (the bakery, the store, etc.). She also gave me sensations (i.e. movement, texture, color, and also number).

We then developed symbols to stand for each category of clue; after that we talked about other ways the directions might have been given. I asked if anyone could give directions using just one or two of the categories that we had listed, or if they could give me directions and distances just by using landmarks. A clue that wasn't mentioned was time. (They could have given me the direction and the time required.)

Then we talked about other ways people orient themselves. What senses other than sight could be used for directions? What things are constant and what changes? What effects change? We talked about the various aspects of sight such as color, shape, scale, and size. We talked about small orientations and developed some interesting tours.

I hope these few excerpts from my journal and the students' comments will give you a glimpse of the course. There are many pages; these were chosen in a random way. I am not sure that they prove anything other than to provide some voices for the pictures.

You might ask how all this is involved with art and traditional art activities as they are usually understood. I have to begin the explanation with the fact that my primary concern is with the theoretical and experiential problems of painting. The problems are several and complex. But probably what I should say is my firm belief in the role of somewhat modified forms of what is usually called art, drama, dance, and music as the central core of meaningful education. In these activities, four basic gestures for individual becoming are acted out: *predicting* (trying out new modes of behavior or responses that are future possibilities), *retrogressing*, in the constructive

sense of that word (past-oriented action dealing with the unassimilated problems of the past), *integrating* (bringing divergent experience and knowledge into a possibility of wholeness), *reifying* (making things into tangible, understood form). All four of these activities surround a completeness of experience that is taken away by most of the processes of schooling.

Another failure of most schooling is that it avoids the most creative and potent areas of human development: memories, dreams, fantasies, and myths. These are the essences of the arts, the arts being their concrete or tangible form. I am not saying that the desire to make or form is dependent on these, but it is certainly interrelated with them. Thus, it seemed to me that we might look at these areas as wellsprings of creative action and that, by working with them, we might indirectly affect many areas of behavior, social as well as esthetic, and thereby develop more open, active, and tolerant attitudes.

AN EXPERIMENT IN VISUAL EDUCATION

Rita DeLisi

Young children have a strong sense of "thing as thing," of an object in itself, with spirit and value apart from function and history. They seek out things that they love to touch, smell, listen to, and look at, things they love to imitate and become. The program at Project, Inc., was designed to reinforce these and all experiences that contribute to a growth of awareness: experiences of movement and restrictions to movement, experiences of space and illusion of space, of the organic relationships in things that grow, of light and how it activates a surface, of the feel and look of different colors.

One seldom knows for sure how ready a child is to associate what he has internalized in the past with what he explores in the classroom. But I am convinced of the value of repeatedly providing situations in which associations are possible and of allowing a child to make them when he is ready. In short, my hope is that a child will make connections for himself and that being exposed to conditions in which he can make them will help him return to his environment with more insight and provide him with the tools continually to enlarge that insight.

In the kind of art we do in school, we know what we're doing before we do it; in the kind of art we do here, we don't know until we do it.

(Karen, age 8)

A semester in a Project classroom followed a particular structure rather than a predefined curriculum. When the school opened each September, I usually started with a project based on a situation that was familiar to children, through which they could explore a visual concern. I tried to keep the earliest projects simple as well as interesting. In the course of a week the first project or some version of it was presented to each group of children who attended classes. One week of observation gave me enough information to evolve a second project and, if a particular group required it, an alternate project to meet special needs. By the second week I could evolve a third. Sometimes a project was spontaneously given a name by one of the children—for example, "Roads" became the name of a problem on movement; a color problem was called "Secret and Surprise Trips."

Although evolved in a sequence, each project remained a complete entity in itself. With few exceptions, a different sequence of projects could be arranged for the special needs of a group of children outside the school without compromising any of the issues central to individual projects. Since the concern (movement, tension, organic unity, or whatever) of a project is directly related to basic experiences and intuitive knowledge, the potential level of personal involvement in any given project is almost limitless. Once this concern is housed in a specific

project it is easier for a group of children to gain access to it. For example, linear movement is explored through a car game based on roads, linear tension is explored through the movements of an elastic band, and organic unity is explored through the analysis of a plant. But regardless of the focus imposed by the framework, the central concern remains essentially intact and unviolated.

In one sense each project was designed to limit a concern in a way that would make it relevant and tangible for a specific group of children. Still, each framework was wide enough to reach children with a broad range of experience. This meant that although not every child in the school could do every problem, there was no need to separate new students from former students and no need to restrict a class to a single age group.

In a typical visual-exploration class at Project—one of five classes of children grouped in three-year age brackets—a visual concern was explored through a project that included play, discussion, and making an object. A visual statement was the end product of this combined activity. Descriptions of the way this worked in a class session will be included later in this account.

Fundamental to the learning experience at the school were attitudes that evolved from how we approached each other, the objects around us, and our work. Therefore, it is important at this point for the reader to have some idea of the environment at the school before he encounters specific projects.

> Winkie, age 6, asked me if Project would ever be a "school." When I answered that it was one, Winkie realized he was misunderstood. "I don't mean that," he said, "I just want to know if you're still building . . . it doesn't look like a school to me."

The classroom was an extension of our homes. There we shared information, ideas, food; there we brought our friends as visitors as well as pets that were not frightened by the constant activity and noise. These were little policies that many of us took for granted, but it was the intimacy of that atmosphere that provided some of our best moments together. It will be easier to visualize a group of children in action at Project after a few short descriptions of daily procedures.

For example, children who were early for class had a variety of possible activities open to them: they could draw, read, review the day or week with an adult or another child, get involved in setting up, or run around and play. Or if they were tired they could rest. Most children reacted to the environment and responded spontaneously to one or many of the options. Only a few, usually children over nine years old, showed a marked anticipation for formalized activity; for them, unstructured time was a void between two realities.

When we came together for our discussions, seating was a sensitive and important decision that depended on many considerations: the activity, the weather, and the age, number, and mood of the children. Sometimes we sat on a big blanket spread on the floor. Usually an olive-green army blanket that the younger children called "the lawn"; sometimes we sat on benches set up in a circle in the center of the room or around a large table. Every class had its share of "floor children" and "bench children" and regardless of what the majority of us sat on usually one or two children chose an alternate whenever the situation permitted.

Setting up for individual work was a way for a child to experiment with the methods that worked best for him. Each child had his own style of setting up. There were children who surrounded themselves with casually arranged materials, so that paint tins could be found on all sides of their paper; and others who kept their supplies

8–1. A class of pre-school children seated on "the lawn." There is a time to work, a time to talk, and a time when the two seem to go together.

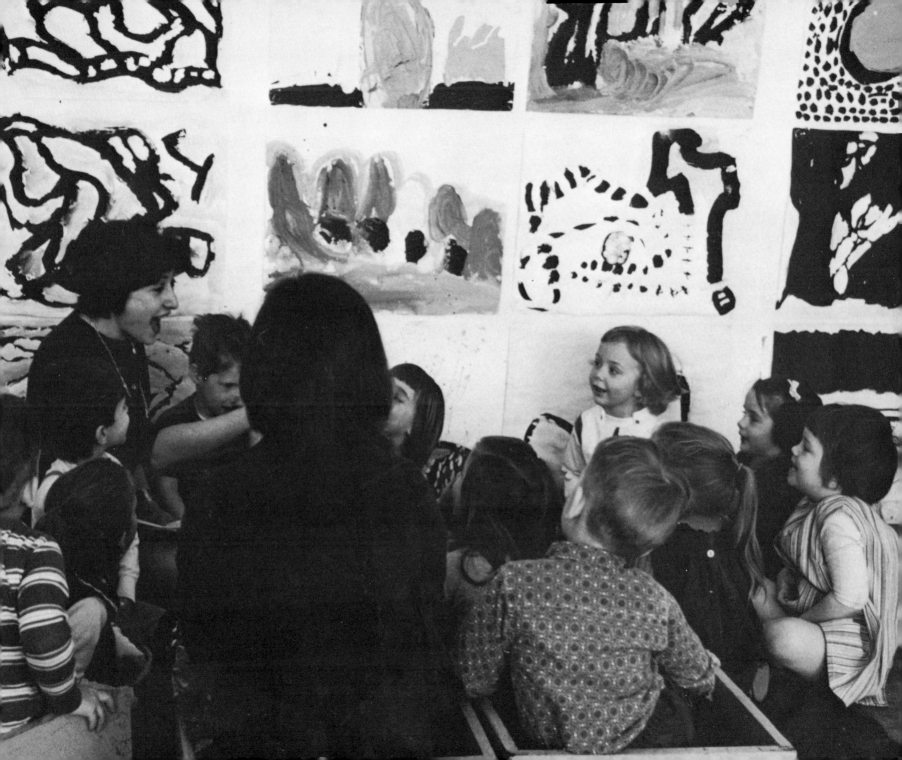

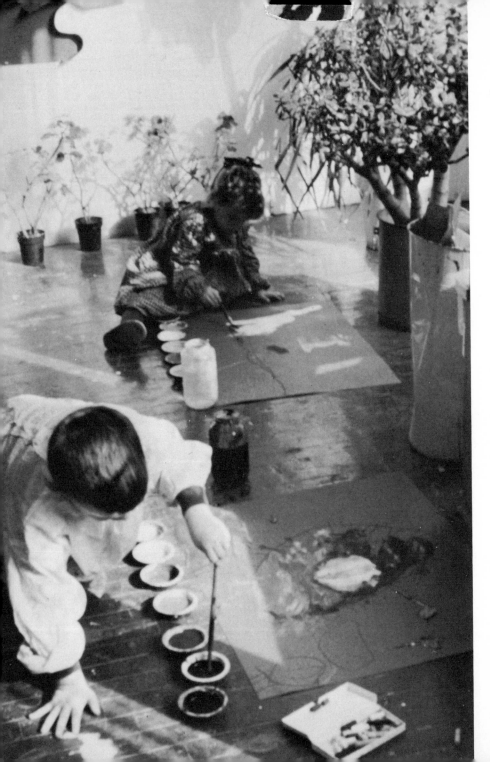

within a well-defined space and usually set up their tins in a row along one side of their work space. Different approaches seemed to work equally well for different children and change was suggested only if a particular approach frustrated a child's ability to work or interfered with other children at work.

Materials were rarely limited at Project. If a child was dissatisfied with his first attempt to resolve a problem, there was extra paper on which he could try again; children who wanted to could make more than one painting in response to a project. (The record number was seven.) My insistence on abundant materials may have grown out of my own negative experience in art class. When I was in grade school, the weekly art lesson began with a warning from the teacher, who reminded us that a five-cent fine had to be paid by any child who required a second sheet of paper because he had "spoiled" his original 9" × 12" sheet of manila. My damp hands are what I remember most and the ugly ripples they left impressed in my drawing. I am sure there are no more five-cent fines, but that does not mean teachers are not capable of inventing more subtle ways to keep the children from exploring and learning while they go about the business of saving paper.

From what I could observe at Project, when children worked on a job that meant something to them, when they were engaged in what they were doing, the "problems" of carelessless and waste just ceased to be problems. That is not to say that the children did not make a mess and that they did not use a tremendous amount of material; they did. Still, the materials were used up not because the children were destructive but because they were involved and needed those materials to to find things out.

8–2. Pre-school children at work. Both the tables and the floor were used as work surfaces, and unless a project was limited to one by necessity (usually size) the choice was open to the children. Total flexibility of the environment was encouraged.

When I first started to teach children, I tended to think of destructive waste in terms of personal problems of particular children; but I eventually discovered that it was not always that simple. There were occasions when destructive waste pointed up some serious problem in my teaching. Sometimes wasteful disruption was a way for children to let me know that the structure in which I had placed them, and to which they were expected to respond, had little relevance to their experience.

What follows is a short description of three Project problems: "Fences," "Letternets," and "Growth." Although they represent only a small fraction of the projects developed at the school, they do give the reader an entrance to the Project classroom and some evidence of the specifics involved in our attempt to develop esthetic consciousness.

The fence problem began with a play situation. The group sat in a circle on the floor. In the center of the circle I set down a large white sheet of paper and told the children to think of it as a piece of "property" that we were going to divide by using fences. There was one stipulation, however. For fences we would use the numbers 1, 2, and 3, all or just one, whichever we wished. Together out of black paper we cut many 1's, 2's, and 3's of different sizes. We experimented with them—laying them down, turning them over, looking at them upside down and backward to find different ways of fencing off the property. The children welcomed the chance to try some ideas without necessarily identifying with them, to get things started and break through the initial reserve. As usual, working together was just a way to move toward working alone.

The children were struck primarily by the humor of the fence problem, and it was meant to be funny in the

8–3. Graphically there are many ways to express a fence. There were children of all ages who treated it from a total aerial view and offered a plan. The children enjoyed the radical shift of perspective that the problem demanded.

sense that it encouraged the children's sense of play. But it was also a defense against the limitations sometimes imposed on imagination by symbols and functionalism. Children can quickly lose their sense of play when they learn the practical or symbolic values of things. This project allowed them to use numbers as shapes or patterns, without imposed meanings. Cutting or tearing his own numbers from black paper showed a child that his 3 was different from another child's 3, and it gave him the opportunity to enjoy the shapes of numbers as their own expressions.

A second project that explored the same idea was the letternet problem. Just as the fence problem provided a framework through which we could look at numbers as patterns of lines, the letternet problem made it possible for us to look at letters of the alphabet for their own sake rather than as symbols for something else. To introduce the problem to the children, I painted the letters of the alphabet, linked netlike, on a large piece of foam rubber. Since the foam rubber could be compressed as well as stretched, it acted as a device through which the children could observe and play with the visual contraction and expansion of space. Together the children and I played with the foam rubber and watched the lines condense and thicken as we pressed against different areas. By the responses to my questions I could see that the children were aware that the letters were linked. When I asked them whether they thought it was possible to draw a network of letters that appeared stretched or condensed like the letters we saw when we played with the foam rubber, they seemed interested in trying.

The letternet project can be seen as a very sophisticated manipulation of space or as a simple exploration. Regardless of how it is understood, it allows one to link letters into a web with other letters, to stretch them from

8–4. Two eight-year-olds presented a mixed perspective in the fence problem, combining a plan with an elevation.

8–5. One departure from the property and fence idea was taken by an eleven-year-old girl, who found a strange face unwittingly taking shape as she worked on her fence problem. She liked what she saw and completed her painting as a mask.

8–6. Children included their own names in the letternets, repeated rows of letters that they enjoyed working with, or linked together a list of freely associated words.

8–7. Children were encouraged to stop periodically and check their nets. They could consider their work finished whenever they felt it was visually satisfying regardless of whether or not they had cut open all the spaces.

the top, the bottom, the sides, to look at them big or little, upside down or backward. For children, it may be a way to write a secret message or to see their names stretched over a whole sheet of paper. More importantly, it is a chance to approach the familiar and the known in a new way without learned meanings and to appreciate it for itself.

> Upside down Upside down
> I went to town Upside down
> I saw a dog Upside down
> Upside down
>
> Upside down Upside down
> I wore a smile Upside down
> You saw a frown Upside down
> Upside down
> (Beary, age 8)

8–8. One child found cutting difficult, but her letternet had an incredibly expressive edge. No one could help her, because the look of her net depended strongly on the way she cut.

Growth is the last of the three projects I have chosen to include in this report. For its presentation, the classroom required special preparation. It was stripped of everything and set up with a varied collection of plants: tulips, crocuses, cyclamen, Jerusalem cherries, oleanders, patient lucies, geraniums. They were placed on benches as well as on the floor and they looked especially powerful against the stark white walls.

As we examined the plants, I explained to the children that, like the plants, drawings and paintings are made up of many parts and the parts have to belong to each other at the same time that they make up a whole. That was one of the things we could learn from the plants. The plants also showed us how things that grow change from one part to the next—a branch, a stem, a leaf; a branch, a stem, a berry—and how, once they have grown to a certain point, the end of that growth is marked in a special way by a leaf, a flower, a bud.

To help them understand what I said, I pinned a strip of black paper to the wall. "Can you think of that paper as a black line?" They told me that that was easy. "Can you make the line 'grow' into a drawing?" They took turns, worked together, and developed the thin paper line into a drawing of a plant.

Each child went on to work alone, directly on the homosote walls of the classroom. For materials he used long black strips of paper and straight pins. There was ample wall space for each child. "Don't plan your drawing in your head," I suggested. "Let it grow as you 'draw'."

8–9. One of the most discerning remarks about the project as a whole and his own work in particular came from an eight-year-old boy. "Look, Rita," he said, "it's not a net, it's a wall with holes punched in it." He had seen for himself the difference between the interdependent spaces of a net and the independent openings which he saw in his own work.

In some cases it seemed a pity to take a drawing apart, but the drawings were never intended as anything permanent. Their purpose was to give the children a chance to explore the growth of a form with maximum flexibility and without the burden of an end product. The most meaningful part of this experience was in the process.

In the following week the identical problem was approached in a different way. It had two stages. First, the children were to make a large line drawing of plant forms with black paint over three sheets of paper that were taped together. They were then to separate the drawings and complete each section as a painting in itself totally apart from the two other sections. I explained that when the drawing was complete the papers would be separated from each other and no longer be considered parts of one drawing. "When you are finished," I said, "try to see the lines you made on each paper as *beginnings of a painting*; use them as a starting point and work on each section individually until it looks and feels complete to you."

The notion of growth was applied to a total organization, whether the subject was roads or plants, not to a literal interpretation of growing things. Once a child painted, the line drawing was only one aspect of the statement. It was a beginning; it set up movements, defined areas, implied tensions. But the complete realization of the painting came in terms of a child's development of those directions; the aspects he strengthened and those he minimized. An organic painting was one based on principles of life and growth: integrity and oneness, relationship of parts, and a sense of presence and completeness.

Many of these things could not be explained by words but I tried to help a child see them through his own work.

Every week there were exhibits in the classroom through which a child could experience the visual impact of his work and the work of the other children in a new and more objective perspective. Once a painting was removed from the workshop, from among the paint tins, the water jars, the wet brushes, it became easier for a child to approach it for itself. When he saw the painting after a lapse of time and in a new context, he was able to see it as it was, rather than as he had meant it to be or as he remembered it. In most instances the painting was a new experience that was different from but as satisfying as the process.

In the course of a school year, the students at Project acquired many skills, took many risks, and learned to judge their own successes and failures. They worked on simple projects in which the materials were limited and the situation was structured as well as on complex projects with fewer controls. They explored projects that made them confront the end product of work as something separate from themselves and other projects that involved them as participants in solutions. Project served as many things for many people, but ultimately the function of its classes was to affirm and develop a sense of power in each child through the experiences he had at the school: power to make something beautiful, power to change the environment, power to say something in visual terms, and power to find satisfaction and enjoyment in visual things.

8–10. In the growth project, the children developed three parts of their original drawings as separate paintings. They treated the original black line in different ways. The child accepted the spaces defined by the line but destroyed the line itself.

Don Seiden THE METRO EXPERIENCE

These pages describe the events and programming that led to the formation of a new class at the School of the Art Institute of Chicago in 1969. The program consisted of two groups of students brought together to explore various concepts in visual arts and human awareness. The group of high school students represented Metro High School in Chicago—"The School Without Walls." This school is described more fully in the following pages. The other group was comprised of students of the School of the Art Institute of Chicago, all of whom were art education majors in the teacher education division. The background of experience that resulted in the Metro program is important to the significance of the new class.

It took too many years of my experience as an artist and as a teacher for me to realize that the two endeavors, art and teaching, are more closely related than I had been aware. When the realization took hold and the intimacy of these two kinds of experience became apparent, I then became concerned about investigating the psychological origins of the art product. I recognized that the nature of my own art production would change as my life involvements changed. My attitudes, personal relationships, thoughts, and feelings outside art had at least as great an influence on my art as skills, professional contacts, and other more obvious art involvements seemed to have on my life.

The awareness of my self as an entity operating simultaneously in the perceptual, conceptual, and physical worlds led me to believe that art education is more than a training ground for learning skills. It is possibly the most effective area of study in terms of guiding others to see themselves as whole people operating at peak levels. Art education seemed to offer an opportunity for students to become involved in the sensory, emotional, rational, creative, and physical aspects of self in a more comprehensive way than other more specialized disciplines offered.

Unfortunately, many art classes seemed at the time to be as traditional and limited as more academic studies did. It seemed that informational rather than experiential learning was blocking the development of personal growth. Although the emphasis on creative development became a powerful force in the art classroom, it often did so at the expense of perceptual, rational, and skill potentials. We seemed always to move in a linear pattern of growth and on only one level at a time. We could teach only parts of the individual, and these parts were too often unrelated to other parts. The problem became evident: How can the student *learn* to feel, think, and produce? How can he *learn* to be expressive and communicative?

We have always known how to pass on information— that is, facts and skills. We have been capable of delivering concepts and values. We seemed, however, to be unable to tie the art experience to *life* experience to more students in an emotionally significant way. It appeared that we had no means of teaching that involved students'

feeling. Even art experiences that should allow students to share feelings as well as ideas and products seemed limiting.

The human-potential movement in psychology, which produced the Esalen experience, T-groups, and encounter and self-awareness groups, opened the possibility of incorporating such methodology into the classroom. Education and self-awareness are inseparable, and any means that will help an individual toward self-realization (according to Abraham Maslow's definition) should be utilized.

Art classes seemed to be beautifully appropriate environments for the attempt to educate in an integrative manner. The art class has traditionally been the room in school where expression, creativity, and freedom were most valued and where the art teacher has had the potential for unifying many diverse activities

It was with these ideas in mind that a seminar entitled "Art and Psychology" was begun in September 1967. The division of teacher education at the School of the Art Institute of Chicago (SAIC) called together representatives from all branches of psychology to participate in a seminar with art education students. The format was simple. Artists and scientists were invited to present any material that they felt was pertinent to the relationship between the two disciplines. Subject areas dealt with such topics as origins of creativity, personality and characteristics of the artist, significance of the art product, art and mental health, art and society, as well as many side topics that arose spontaneously from the discussions.

The seminar produced a great deal of information and generated enthusiasm for new ideas in curriculum. Perhaps the most important insight occurred when we realized that we had gone to the "experts" only to discover that each individual including the experts has his own

9–1. "Tying up the park" produces new space relationships. Will the participant ever walk through the same space and see it in exactly the same way?

9–2. Students change the environment by "tying up" each other and the room. Any space can be adjusted through limited means. The use of string encourages swift (and inexpensive) transformations.

bagful of problems and personal solutions. How and through what experiences did these people arrive at their own solutions?

Then it all came down, and we understood. Why not allow each student to consider himself an expert, since he too has had experience, and let him ask and answer his own questions? Too simple? Well, we realized that this approach was a kind of regression, albeit a healthy one, because it assumed that the student had the answers within himself and that within a nurturing environment he could discover them. A further assumption was that if a student desired to develop and grow in his art, he would also have to understand his growth as a person. In this framework the question "What is art?" was not so different from "What is life?" and, posing these questions even more directly, they became "What is art to me?" and "What is life to me?"

We assumed further that a classroom that encourages open communication, both verbal and nonverbal, will allow students to communicate more honestly, be more cooperative in the group, relieve anxieties by sharing them with others, relax defenses so that experience can be fresh, replace undesirable values for more significant values, and ultimately become aware of "real" meanings in the art experience. And so the route was laid out and now we had to test the concept.

My class in art education methods took on a new look. I was no longer the teacher. I became a participant sharing my own experiences and resources with the others. Dynamic exchange of feelings and ideas replaced defensive, formal discussion, and honest feelings were investigated for their potential ideas. Exercises for stimulating perception and sensitivity were explored. Although many of these exercises were adapted from the human-

9-3. Problem: Radically change your identification from person to object. Art overlaps into theater as the student "acts" his way into a new identity.

9–4. The human form is freely manipulated into sculptural forms.

potential experience of encounter and T-groups, they were designed to relate primarily to art. For example, a group using kite string went outside and "tied up" a park. The experience resulted in a fresh understanding of spatial relationships. This was followed by "tying up" our classroom. The room became a giant web with a whole new space concept. Both experiences provided an opportunity

for the group to share personal feelings and action as well as gain some esthetic insight.

We attempted to explain the artist's relationship to materials by having members of the group move each other's bodies into sculptural poses, creating human sculpture and "constructions," using ourselves as material. Resistance, plasticity, and negative and positive space all

9–5. Art teachers have traditionally concentrated on the visual and tactile senses. Students here are describing smells as part of their sense exploration.

became more meaningful in this highly interpersonal relationship. Role-playing, in which each person "became" one section of a painting and held a spontaneous conversation with another part of the painting, brought a new meaning to the analysis of art.

The class ultimately became welded together into a new and effective learning group. We were free to explore people, places, and things in an honest, uninhibited fashion. Here there were cooperation, less competition,

and the potential for understanding tradition and innovation in art without the pedantry and formality that have so often dulled the true passion of the art experience. The dry run had proved successful, and so we moved into the next phase of our program.

In September 1969, we designed a program at SAIC that was to accommodate two groups of students: one group representing high school students from Metro High School, the other from the teacher education department

of SAIC. Metro High School is a pilot program of the Chicago Board of Education, lately referred to as "The School Without Walls." The student body represents all the high schools in the city. Metro students travel in and around the city, using businesses and institutions as their classrooms. Their work is accredited by the board of education and their courses may range from creative writing at the University of Chicago (English credit) to electronics at Illinois Bell Telephone (science). The course at the Art Institute for the Metro people offered credit in art.

The two groups came together in our class with some ambivalent feelings and anxiety based on the wide range of age, experience, and interests. Most of the fears were alleviated when everyone was asked to make some response to the question "How do you feel right now?" It was discovered that we all shared some anxiety, and the ice was broken. After some introductory exercises, we began to learn about art, each for ourselves and with the help of others. The introduction exercises were:

1. Stand up, feet apart, eyes closed; relax. Leader: "The space surrounds you like a column. Slowly lift it off of you and hold it up over your head. Now gently let it down around you."
2. Relax, eyes closed. Listen to sounds.
3. Open eyes. Without moving your head, take in as much space with your eyes as possible. Now move your head and take in the space visually.
4. Pair off. One person closes his eyes and the other leads him for about ten minutes. Exchange roles (the "blind" person becomes the seeing one leading his partner). The experience should be tactile and spatial as well as a "trust" experience.
5. Break up into small groups (making certain that members of Metro and SAIC are represented in each) and hold a spontaneous conversation for about fifteen minutes.

The classes ran for two and a half hours, so at this first session as many group activities were employed as seemed necessary to contribute to easing the natural tension. Feelings of acceptance were established and more exchange was the result.

The ease of the atmosphere in the second session was apparent. The "vibrations" were good, and we began to get into composition, arrangement, and relationships in a work of art. Everyone was asked to take a personal object and place it in the center of the room. We then described each object as if it were a person. We gave it human qualities: it was feminine, bright, stable, eccentric, graceful, strong. Each "object personality" was then placed in relation spatially to another, and the relationships were then described: hostile, dependent, loving, dominating. We continued by adding one object after another to the group, and each person changed or shifted the arrangements to illustrate possibilities.

At this point the students divided into groups of four. Each four surrounded a large drawing paper and were asked simply to draw whatever or wherever they wanted on the paper. The limitations to this exercise involved no discussion and one piece of chalk or crayon to a person. At the beginning, each person tended to draw in a chosen part of the page and did not immediately "invade" anyone else's "territory." Soon, however, some brave soul would venture forth on the paper and the others would follow. The results were often chaotic, but just as often a group would find itself working toward a common goal with each person taking on a special role: the coordinator, the decorator, the innovator, the stabilizer, and so on would all arrive at a consensus without verbal conversation. Discussion regarding the compositions after the exercises ranged from esthetic considerations to group dynamics and helped to form concepts regarding these facets. The feelings of each person were aired again in relation to the others and their part in the group effort.

Each person then was asked to think of himself as a shape, any shape. A paper was passed around the room and each student placed himself on the page, translated, of course, into a shape. Volunteers were told to impose on

9–6. Relief sculpture created by the group is discussed and evaluated. Students do not retreat from verbal expression as a means of clarifying their responses to art objects.

the composition anything that they felt would pull it all together. The results were borders, outlines, solid shapes, repetitive designs, and other means of unifying.

Students were then asked to create a composition using any drawing material that would illustrate group dynamics without using recognizable images.

The next couple of sessions were devoted to analyzing the structural elements of a visual product. Again, exercises that related personal experience and insight to formal structure were employed. If we dealt with color, we would attempt to relate to other people as if we were a color. Verbal conversations were held between colors,

9–7. In a ceremonial parade, students deliver a sculpture from the School of the Art Institute to Metro High School.

and nonverbal movements and gestures illustrated their relationships. People came to class dressed in their own colors and arranged themselves on the floor into a "painting." We filmed and photographed these works.

When we were discussing line, we might arrange ourselves in rigid military fashion or turn out the lights and mill around spontaneously, trying to document our patterns mentally. We used kite string and created linear patterns inside and outside. One group proceeded to "tie up" another group, which then attempted to walk down the halls as a large organism all bound up. Each student was asked to create a composition charting the move-

ments of a group of people, traffic, or any other event using linear devices.

After elements of two-dimensional work were explained, we then directed our attention to three-dimensional work. People were asked to move their own bodies spontaneously into shapes, then to move a partner's body into a pose, and finally to arrange a group construction, all this without conversation. The possibilities of understanding space, shape, and engineering can be immense in such experiences, depending on how each student views his involvement. Much of the emphasis on motion, touch, and resistance and flow can lead to more self-awareness as well as to art awareness.

At this point, each person was instructed to close his eyes and make something of clay. After completing their projects, the students were asked to describe their objects but instead of calling the results a "sculpture" they were to substitute the word "I." Descriptions were then given that both fit the object esthetically and were another experience of self: "I am a wobbly form with thin legs," "I am open and trying to fly," and so on.

The students paired off and one directed verbally while the other worked on the clay. The director described how he wanted the clay shaped. The artist simply followed instructions. Discussion followed.

After this exercise, the students paired off again. This time they were asked to work alternately on the same sculpture. While one observed, the other worked. The observer in each case was to try to describe his partner's work approach. Feelings and observations were again discussed after the exercise, in order to discover what was experienced.

We proceeded to investigate tradition by interpreting paintings and sculptures by playing roles in the parts of the work and by spontaneous stream-of-consciousness criticism and response, using slides and films when appropriate.

Rituals were created by the whole class. The rituals were designed to move the group to a common response toward some basic concept.

The class always reserved time for spontaneous discussion of occurrences, whether related to art or not. The school's library, video equipment, sound tapes, and other resources were put to good use. Other art forms such as dance and drama, and many other activities were also incorporated into our experience.

In retrospect, it seems that class involvement maintained peak activity when group involvement or individual projects were worked on. Discussion and lecture were not always successful, particularly for the Metro group. The Metro students seemed to respond best to experiences that involved some physical activity and that were not limited solely to verbal discussion.

The outcome was a closer tie between teacher and students, a more human, honest classroom situation, and an environment in which learning took place because it was desirable to learn.

Esthetic education for young people begins with joy. The feelings and concepts associated with everyday experience can be translated through art and become significant because true learning is joy. Human sensitivity, perception, and communication can be expanded through the arts in a way that is both appropriate socially and desirable to the individual. Programs like the Metro group seem to implement conscious learning in all areas of feeling, perception, and expression as well as perpetuating the conceptual and practical skills.

The role of the arts in general education is rapidly becoming more necessary as the core of other areas of concern. Esthetic values that stress expressive joyful behavior must be passed on to young people in a way that is humanized, personalized, and deeply significant to people who wish to live in an environment suitable for humans.

REDEFINING THE NATURE OF ART: ART FOR SOCIAL PLANNING

Richard Neutra provides a link between architecture and life in the title of his book *Survival Through Design*.[1] And Jan Wampler's conception of design leads him to believe that the ordering of one's environment for the determination of a desired life style is a valid premise not only for art education but for general learning as well. There may still be some question as to the appropriateness of Wampler's program in a book on art education, yet if one is willing to admit that design involves the arrangement of formal elements for particular ends, if one concedes that designers determine the way the manmade environment will ultimately look and function, then it becomes obvious that education in design is not only desirable but inevitable. One difference between the designers in Wampler's program and the artist-designer in a more conventional sense is that the children of the Warehouse School had to abide by the limitations of space, money, and function. The fact that their choices were thus limited by certain predetermined conditions in no way diminished the quality of their thinking or feeling, any more than the stature of a potter suffers because the properties of clay determine to a degree the nature of ceramic design.

[1] Richard Neutra, *Survival Through Design* (London: Oxford University Press, 1959).

To believe in art as social design is one thing; to develop ways in which such an idea can sit at the heart of curriculum is another matter. Wampler, an architect who had children enrolled in the Warehouse School, was presented with an ideal opportunity to plan such a program, and he was fortunate in having the support of a community of parents, teachers, and children in carrying it out.

The Warehouse School is one of the emerging "open" or "counter" schools, and any art produced in such schools is bound to be shaped by the philosophy of freedom and self-determination that distinguishes them from most public schools. Open-school approaches do not necessarily imply chaos. Indeed, the infant school movement in Great Britain demonstrates the need for even greater planning, because in them children are expected to operate as individuals, setting their own pace for the selection of materials and activities. Barbara Leondar reminds us that most open schools work from the assumptions that less structure is better than more and that more student control is better than less.[2] All open schools support student-determined curricula and place special value upon independence from centralized authority, and all such schools seem to be self-consciously aware of their avant-garde role in the protest against establishment education.

[2] "The Arts in Alternative Schools: Some Observations," *Journal of Aesthetic Education*, 5, No. 1 (January 1971), 75-91.

THE WAREHOUSE
COOPERATIVE SCHOOL

Jan Wampler

The Warehouse Cooperative School is located on Mt. Auburn Street in the basement of the Armenian Church Community Center in Watertown, Massachusetts. The school was organized in the summer of 1969, that school year being its first year. It is school for sixty-five people, ranging in ages from five to seventeen years and representing a cross-section of the economic incomes of the greater Boston area. Financially, the school is an economic cooperative, meaning that tuition is based on a percentage of parental income.

The main room of the school is a sixty-by-ninety-foot space located in the basement under the gymnasium. Acoustically the space could not have been worse designed; the ceiling is approximately nine feet high, and the room is completely enclosed in walls of concrete. There are no windows for outside light or ventilation. Many activities happen within this open space all day that change its definition from a ballfield to a study space to a classroom. The continual free interaction of ages and interests in this space is the visible result of the open chance for learning in the Warehouse School.

The Warehouse School had been in session approximately four months when the older students announced that something must be done to improve the environment of their school, primarily to give it some self-control and order and some acoustical treatment.

The general nature of the school, particularly in the main room, was chaotic. Structurally the room contained a six-by-three-foot space for each student and approximately six to eight work areas located in the center designated for carpentry, painting, pottery, science, and free use.

Three negative qualities were immediately apparent. The atmosphere of freedom, combined with the acoustical problems of the space, made the school a noisy one, and adding furniture and wall hangings did not reduce the sound problem. The freedom also allowed the younger students continually to invade the work spaces of the older students, disrupting the learning process and sometimes destroying projects in inevitable accidents. Finally, the layout of the individual spaces did not stimulate a great deal of development. A few spaces became personalized, but most students knew that the disorder would destroy whatever they created.

So I was asked as a parent and an architect to design a space for the school to help with these problems. My concern was twofold: to preserve or conserve the spontaneous quality and to design a school that would reflect as many of the students' ideas as possible as well as the parents' and the staff's, so that the actual design process would include these people and not be the typical architect's idea of what a school should be.

10–1. "First you came in with a little piece of paper and you had a little drawing on it. And everyone started handing out ideas. You put the paper down in front of 'em and we all scribbled so you brought in a whole big roll of paper." (First sketch of design for school.)

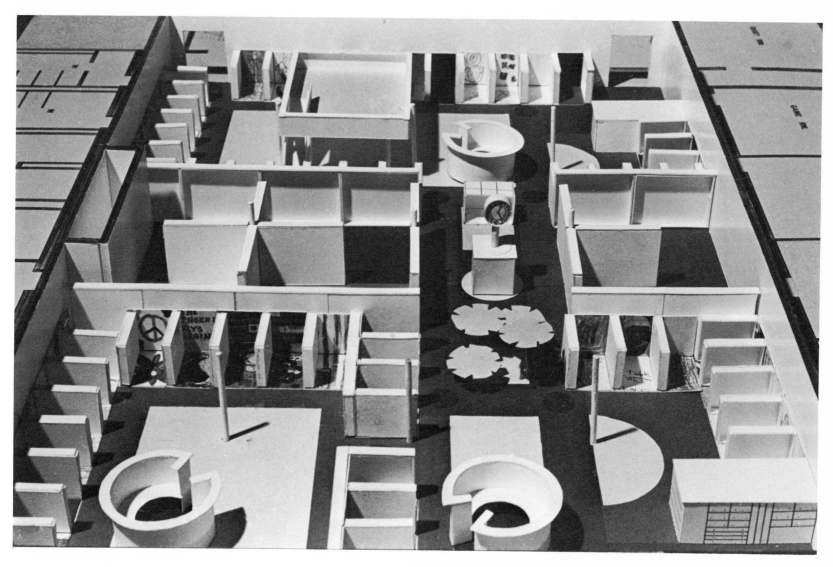

10–2. "And then we decided to build a model to see what it would look like on a little scale. . . ." (The model shows individual houses, streets, public spaces and City Hall.)

Do you think from an architectural standpoint
that it was helpful to you to participate in the process,
or would you have liked an architect to design the school?

Oh no! That would have been awful! Because then like
you'd come in one day and it's all there and you say "wait
a minute, I don't like this" and then you have to spend
about thirty zillion more dollars to get it all done over
again and this way you sort of know what's going to
happen and why you can't do this and why you can't
do this.

The project took six weeks from beginning to completion,
on a budget of approximately one thousand dollars. I met
with the students, parents, and staff usually two times
each day, at lunchtime and after school, to discuss what
they wanted in their room. We went on field trips to the
M.I.T. architectural studios, where the students there have
built their own environment within an already existing
one, and to a used-lumber yard outside Boston, where we
found inexpensive materials to use in the school.

We then started a series of design meetings. I drew a
sketch and the students and the staff and whoever was
around would make their corrections on the sketch with
their ideas. The initial advice that I gave, only verbally,
was to think of the room not as a dismal environment but
as a potential reflection of the school, to think of the
school as a village, and to think of the idea of frameworks
in which the students could participate.

Could you explain the process, what you saw?

Oh yeh! Well first you came in with a little piece of paper
and you had a little drawing on it. And everyone
started handing out ideas. You put the paper down in
front of 'em and we all scribbled so you brought in a
whole big roll of paper. Just doing and doing and doing
and we just redesigned the room like many many times
and figured out what we could do and from all kinds
of standpoints.

The first sketches simply indicated the basic idea
that a village or small city has streets, parks, stores, pub-
lic buildings, houses, neighborhoods, and even industries.
We looked at these drawings and saw what the floor plan
of the school had in common with the plan of a city, and
we talked about the city problems that we wanted to avoid
in the school. The sketches then incorporated these grow-
ing ideas.

A second sketch indicated the various neighborhoods,
one each for the younger students, middle students, and
older students. There also were four central areas desig-
nated for art, ceramics, and woodshop use. I asked the
students if we should have something in the school similar
to a city hall, if in fact we needed a city hall or wanted it,
what was good about a city hall and what was bad. They
decided that they did want a city hall and that it should
contain the public telephone that they all use during the
day, the refrigerator that keeps their lunches cold, a
cubbyhole device for each student's mail, a mirror, a
clock, and a place for making coffee. One boy wanted a
place to hide, which I thought was a great idea of what
a city hall should be. So their city hall was then drawn
somewhat in the center of the school and surrounded by
a green area that was called the park.

A later sketch pretty much firmed up the basic ideas
of having the city hall and park in the center, with an
animal farm at one end and a lounge or tree area at the
other end. There were now two neighborhoods, for the
young children and the older students, and each had a
community center, small central areas in which people
could eat lunch or have a discussion and some privacy.
The public areas had increased from four to six. But in
the process of the planning, the middle students had lost

10–3. "What about the idea of you building it yourself and
designing it yourself?"
"I liked that."
"Oh yeh, that was fun!"
"That was much better than having anyone else do it."

their neighborhood space. So they sent a representative to one of our luncheon meetings who said that he did not think that they were getting a fair shake. We then redesigned the whole scheme to include the middle neighborhood.

The younger students also had objections at this time. We had decided earlier that the younger students would have three-foot spaces, the middle students four-foot spaces, and the older students, five-foot-spaces. The younger students objected, saying that they used as much space as the older students. The scheme again had to be changed, with every student having a four-foot space, which in fact turned out to be a definite improvement because the younger students do need just as much space as the older ones.

This process took about two weeks and produced a plan that accommodated almost everyone's ideas, the parents', the staff's, and the students'. The plan was then translated into a model, again by the students, the parents, and some of the staff. On the first evening, about ten people met in my office to build the model. My office holds about two people comfortably. During the evening, they managed to cut up all the Bristol board and their fingers, destroy other models in the office, and accomplish absolutely nothing. But we all had a good time.

The next evening was more productive. In about a week, the students built the model reflecting the idea of their last sketch. It showed the floor painted different colors to indicate different uses—brown for the streets, yellow for the community areas, green for the parks, and other bright colors for the public working areas.

What about building the model?

10–4. "Do you think that the design of the whole thing restricted anybody's ability to participate or do their own thing?"
"No, the little kids just had more neat things to climb over."

10–5. "Some of the spaces worked out really good!"
"... she got hers all fixed up and all painted and all splashed all over everyplace. . . ."

It was great because really I didn't realize what an architect had to go through—oy!

The small students were to have a double space in their areas that anyone shorter than four feet could use because that was all the head room that existed there. The city hall was designed, and the community centers became

small circles four feet in diameter with benches inside where anyone could eat lunch or have a meeting.

> And then we decided to build a model to see what it would look like on a little scale so we just kept traipsing over, you know, to work on the model and then over Christmas vacation we just got a mess of wood and stuff and what we needed and everyone chipped in and built and painted and everything.

In addition to the ten people who were involved in building the model, everyone in the school participated by drawing a design they wanted to see on the floor and the walls of their house, in terms of either painting or interior decorating. They were asked to think of a well as their outside window. These designs were not to be the final schemes but were only to identify the spaces on the model and to realize visually the school's potential.

The sketches ranged from abstract paintings to detailed location plans of furniture, chairs, coatracks, benches, bookshelves, plants, weaving machines, a little bit of everything. Small students drew chairs, sometimes out of scale. Some drew American flags or great abstract personal messages. And the peace symbol was always a theme.

These sketches were then cut out and glued into the framework of the space, so that when the model finally was brought to the school, instead of seeing his name on a space, a student saw his own design. Then he could start moving his space to the neighborhood he liked. The space, delimited by four-foot high partitions, was four feet wide and five feet deep. It could be moved anywhere in the school as long as the former occupant of the area agreed to move somewhere else. In the corner, communes could be built, so in some cases four people utilized their spaces collectively.

How did people pick spaces?

It started out when everyone drew a picture of what they wanted their space to be and it didn't have to be that way. It was just an idea so we'd know whose was whose. And then we went through the whole process of what age level would be where and finally, when we decided that, we just put 'em in together and later we asked them where they wanted them approximately, and then we said "if you don't want it there you can trade with someone in another age bracket," and it worked out that way.

How did it work when you traded with somebody? Were there hassles?"

No. We had a few kids do it—like Debbie. She's done it quite a few times. Like she got hers all fixed up and all painted and all splashed all over everyplace and then she decided that she didn't want to be there and so she'd go and talk to somebody and with a little persuasion and pressure she finally got them to change with her, so then she changed and she'd redo her space and splash everything all over again and then she'd decide she didn't like it then, so she'd move into another place and it just kept changing. But there wasn't much hassle.

After the model was built, and the students had decided on the location of their property and planned their neighborhoods, we started the monstrous building program. It took place over the two-week Christmas vacation, again involving a lot of the students, parents, and staff. The thousand-dollar budget purchased principally the half-inch plyscore framework items and the floor paint.

In about a week and a half, the framework was built. Then came the horrendous job of cleaning the floor to make it ready for painting. I practiced the principle of using available material and eventually found the yellow paint used by the Public Works Department to paint street lines at a cost of about two dollars a gallon. During this

10–6. "Now, you can build what you want in there!"

stage, the model was the only piece of architectural information, as most of the students knew exactly what they were doing, so it was not a matter of the architect telling them what to do. They understood it as well as anyone else.

During the last few days just before school started, people were up all night painting the floor. At two o'clock on the first day of school, the room was open and the students first saw how the room's character had changed. Someone said that when they let the students into the room, running around in their new spaces, it was like a thousand Christmases. The exciting thing was to see how this framework that I had worried might be too restrictive and destructive of all the beautiful chaos actually promoted more confusion in a very short time.

The students immediately began finding lumber and materials to build their own houses within their spaces. Small students quickly found that by putting wood on top of the four-foot-high partitions they could build a second level. Other students found that they could construct a second-level pedestrian way by interconnecting all the small spaces. Students began to paint their spaces. Some designs were elaborate. Some were close reproductions of the earlier sketches. Others were spontaneous. Chairs and other furniture were found and moved in and, in a very short time, each space had become a house.

Everyone in the school had a space, including the director and the staff.

Students also brought in photographs of their pets and their heroes, which they hung on their walls. Graffiti started to appear. The exciting thing was to see how the

spaces changed each day; every day a new mood or a new idea would appear.

One student decided that he wanted nothing to do with the framework idea and built his own thing inside his space. He nailed together a great wooden tower. Each day it progressed. One day a set of steps appeared. Then, finally, he painted the whole thing black and placed a chair at the top, his sort of throne. Another student enclosed his space entirely and put a door on the front and a light inside, so that he could have complete privacy.

Did the spaces create too much privacy—did it separate you as a group or was this desired?

Mine's really good because it's in the corner and I can get away and they can't see me and they can't find out where I am.

Students also named streets and numbered their houses so that they had addresses, such as 6 Country Terrace, Stillwater, Warehouse, Warehouse being the name of the city and Stillwater the name of the neighborhood.

Students are still changing their spaces, building in them, and using them as a house, a place to study, a place to sit. The Warehouse School is a changing collage of personal expression. The colors and order change within the necessary framework, reflecting the school as an interaction of students and teachers in a learning situation.

What do you think of the way it turned out?

We have improved its terribleness.

It's given those who have space more of a sense of possession. Now they have a space that's theirs and they can completely do what they want with it, whereas before it was just this great big open space.

10–7. "Now they have a space that's theirs and they can completely do what they want with it, whereas before it was just this great big open space."
"It's like being in a cave."

10–8. "Was it worth the work?"
"I like it!"
"I do too!"
"It's fun!"
"It's organized."
". . . what we did was make areas that would appeal to different kinds of people."

10–9. "We go to the Warehouse School. That's the best school I ever went to."
"My school's a place where you're free."

t вt

It's restricted the little kids from running completely all over everywhere, over the big kids and jumping on them and all that stuff. (*Little kid:* "I still run." *Older kid:* "Yeh, but we don't notice it as much.")

Obviously the Warehouse School is not going to change the architecture of educational institutions on a grand scale, but it has helped sixty-five students enjoy their school more than they did before.

What is perhaps most important, this project has helped to redefine art. More than a painting or a piece of sculpture, art is a personal and relevant extension of ourselves into the environment around us, our personalities and ideas made visual. All people should be involved in the making of their environment and changing it as they change. It is essential that we participate directly in the decision process so that it answers our needs.

This article has described one way of changing the environment in a specific situation. It need not be on this scale or in this form. It can begin with the design and construction of a small room or an outdoor space or, in the case of schools, the classrooms that generally are drab, sterile, and uninviting for learning. Instead of a conventional art course, students could work together with educators, study and correct their immediate environments, and improve the classroom, the corridors, and the space outside the school. Perhaps these small answers of positive action to realistic problems are more important and educational than all the grand plans for art education.

REDEFINING THE
MEDIA OF ART

Among the contributors to this book are teachers who are beginning to deal with the problems of art media. They are receiving little help from establishment art education and, as a result, their ideas are highly individual, if not idiosyncratic. Lloyd Schultz has designed his program around a single element of art—light—and allowed this particular physical condition to determine the media that would be considered appropriate. The content of his article "Light Media" lies somewhere between the sensory assault of the light show, which was dropped from the curriculum after the first year, to such exotic light forms as lasers and holography, which are being seriously entertained as a future addition to the course.

Just as a course in drawing demands certain materials (paper, chalk, pencil, and so on), Schultz's emphasis upon light involves the hardware of communication media (still and movie cameras, overhead projectors; *any* paint or material that permits passage of light). The entire program rests upon Schultz's conviction that light, which has traditionally been a concern of painters, sculptors, and architects, enjoys special attention in the

sensibilities of a generation that has been reared on television and is currently fascinated by movies, light shows, and other visual manifestations of the present youth culture. Conventional art elements are used in new contexts; line, color, form, and content are still employed but with certain obvious differences. In a light course, line is drawn with a felt pen and colored inks rather than crayon and pencil, and color is handled with theatrical gels rather than tempera and oil paint.

Schultz, it should be noted, asks his students to go beyond the obvious benefits that are offered by the immediacy and emotive power of his subject. The course is also offered as an option in the final course of the usual three-course sequence in art studio. Unfortunately much of what the exercise offers is not suitable for the usual portfolio required of colleges and art schools. In this instance, at least, Schultz's art "product" may be in advance of the next step on the educational ladder.

LIGHT MEDIA:
A COURSE IN EXPRESSION
AND COMMUNICATION

Lloyd Schultz

"Easel painting is dead!" For the past two decades evidence for the truth of this statement by many critics and art historians has continued to accumulate but without final judgment. Painting on a variety of surfaces continues to be an expressive form for the beginning art student as well as for the established professional. The traditional work of art will exist as long as walls are solid and contain areas of emptiness. One can detect in the emergence of budding art movements, however, new and embracing attitudes for unconventional elements and materials in the formation of the art object—earth, water, fire, to name a few, and in particular light.

Matisse used traditional means to extend the expressiveness of color in painting, yet he envisioned the future when he stated "Some day all art must come to light." He was aware of the limitation of pigments as a means of employing color, for he knew and understood that the painted surface cannot match light color for purity, intensity, and kinetic capability.

Light is the medium of our time. In pursuing it artists, technicians, even physicists, are experimenting with fluorescent tubes, laser beams, strobes, and other forms of electrically created light. Numerous exhibitions of luminal art have taken place internationally with enthusiastic popular reception. Anyone who has visited a light exhibition will agree that these displays are intriguing, often mysterious, and always dazzlingly alive. Many critics while granting such qualities have stated, however, that as art light works are all surface, without content, merely a form of optical decoration. If this is true, the movement will remain experimental play, finally to expire in a welter of absurdity and gimmickry.

Perhaps a backward glance into the history of luminal art will provide some reassurance that this is in fact not the case. Long before the invention of the incandescent bulb, medieval artisans heralded the beginnings of luminal art with their creation of the stained-glass window for the Gothic cathedral. It would be unthinkable to suggest that these windows were merely delightful decoration, for, standing in their glowing presence, one is transported in spirit, overwhelmed with mounting sense of glory and majesty. The windows, the sculpture, the towering arches, the mysterious quality of light, are all functioning for one objective, the glory of God. The message of the Gothic church to the contemporary luminal artist is clear. He must discover an equivalent of the cathedral environment to give his work both esthetic significance and humanitarian purpose.

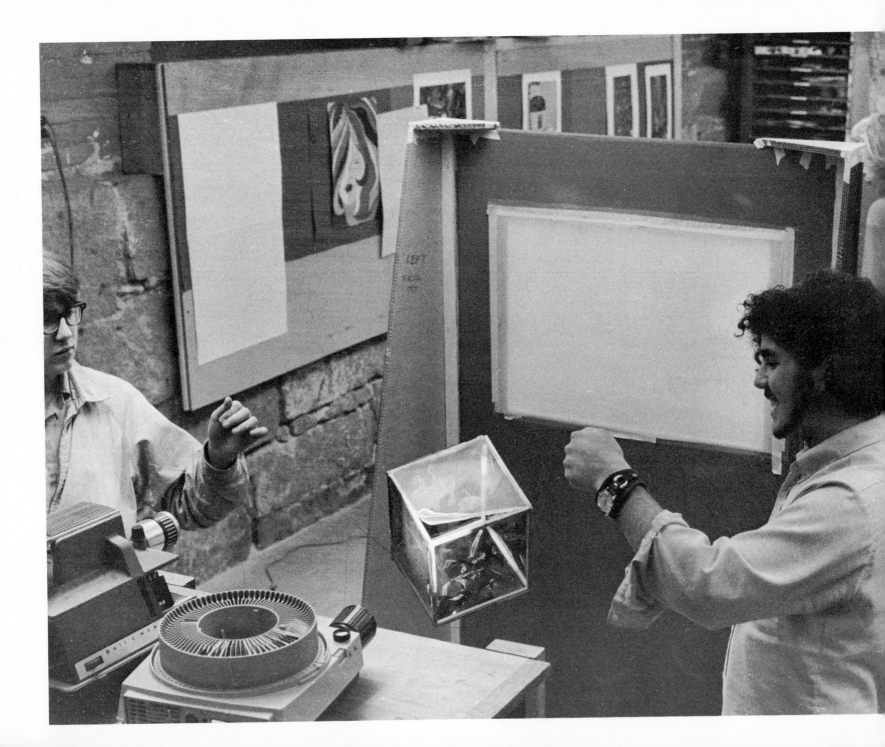

The erection of the Swiss Pavilion at Expo '70 in Osaka, Japan, provided a vivid example of the use of environmental light. The material used for construction of the Swiss building was aluminum, which during daylight hours reflected light with dazzling brilliance and gave the structure a quality of metal sculpture. Also included, strategically placed to give accent to the structural lines, were 32,036 electric bulbs. By day, the pavilion was esthetically impressive as architectural sculpture and by night, with the throwing of a switch, it became a breathtaking and inspiring light sculpture.

Again, the message to the luminal artist, present in this example as in that of the Gothic cathedral, is that he must seek and find a proper environment for his art. The young with "here and now" attitudes have found a temple in the limited realm of the discotheque. But the serious artist, must look to the use of light in a sculptural or communal sense.

With imagination and vision a city can become a garden of light and color. A light artist once referred to Times Square in New York City as a "garden of light." Her choice of the word "garden" seems inappropriate; "jungle" might have been better. Although the use of light, color, and movement in this instance expresses the competitive commercial spirit, the result is visual anarchy. And in such visual license, unfortunately, lies an enormous capacity for growth. One readily witnesses a creeping chaos when traveling on many of our public highways. If this form of visual blight remained on the retinal level, it would not be particularly serious, but it has steadily advanced in depth and now affects the very lifeline of the American spirit. The frenetic desire of each luminal advertisement to outshine and outmove its neighbor has pro-

11–2 Framing is the final step in the making of slides, a classic component of the light show.

11–1. Students test a light modulator by projecting slides through the transparent areas. This problem frequently turns out to be one of sculptural form, thus providing the student with an "inter-media" object.

duced a crescendo of optical hysteria. If a commission had been granted to a luminal artist to transform Times Square into an organized site of mobile color, we might have had the initial example and influence of a truly new communal art.

Cities are now dramatically changing with the construction of new buildings and the creation of new squares, plazas, and community parks. Within these areas, surrounded by exciting architectural forms, one discovers

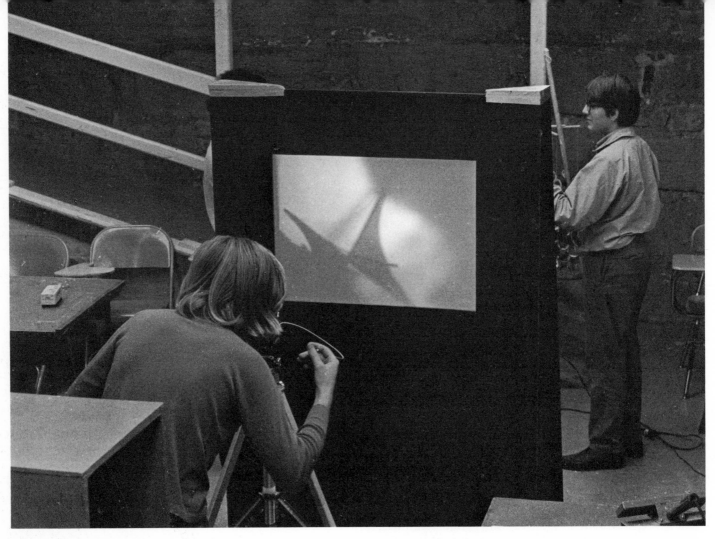

11–3. Combining several media by filming slides and light modulators produces a light film.

inert statuary and water fountains representing an inflexible tie with the past that is distinctly reminiscent of the renaissance. Twentieth-century architecture should be attended by twenty-first-century art.

The light media course to be described in this article does not contain objectives of such lofty social significance as transformations of architecture and the environ-

ment, but it does have certain aspects that can be applied to environmental goals. The three major media presented in the course are photography, slide tape, and film, all of which are related to luminal art but are too complex to be regarded as pure light forms. Since its beginning, the course each year has undergone modifications of program and esthetic objective. Many original concepts embracing

luminal art have been either discarded or given new applications. For the future, a new course in design is being formulated in which light will play a dominant role in confronting our communal esthetic problems.

At the time that the light media course was initiated at Newton High School, the two art forms attracting the attention of the art-minded young were the light show and the multimedia presentation. In the beginning, one of the aims of the course was to provide students with some knowledge of light-related materials as well as actual experience in using various light media as a means of communication and expression. Several factors have since emerged that indicate a change of direction. For example, most contemporary art forms and movements enjoy only a limited life span, and, characteristically, the light show no longer incites the wild enthusiasm that it once did. The multimedia presentation has suffered a similar decline. Current interests and objectives of the students who elect the course continue to influence change.

As originally designed, the light media course was offered only to third-year art majors. They were able to elect for their final year either the light media course or a more traditional one. Most of those planning to continue art in college or art school selected the traditional one. The reason is fairly obvious: the traditional portfolio of drawings, paintings, and designs continues to be a requirement for entrance to most art schools and is still looked upon as the measure of a student's artistic capability. As a result, the light media course has experienced a lack of many art-oriented students. Many students outside the art program, however, have been attracted by specific phases of the course and have expressed their desire to attend. The decision has since been made to open the course to the entire student body, with some qualifications related to the present nature of the program. The majority of students interested in attending are primarily concerned with film-making, and the present direction of the course is toward a sequential introduction to film, begin-

11–4. A student prepares a slide tape, which combines sound and image in a synchronized sequence. This is perhaps one of the most complex and time-consuming of all the areas of concentration. Slide tapes are sometimes prepared in lieu of term papers for other courses.

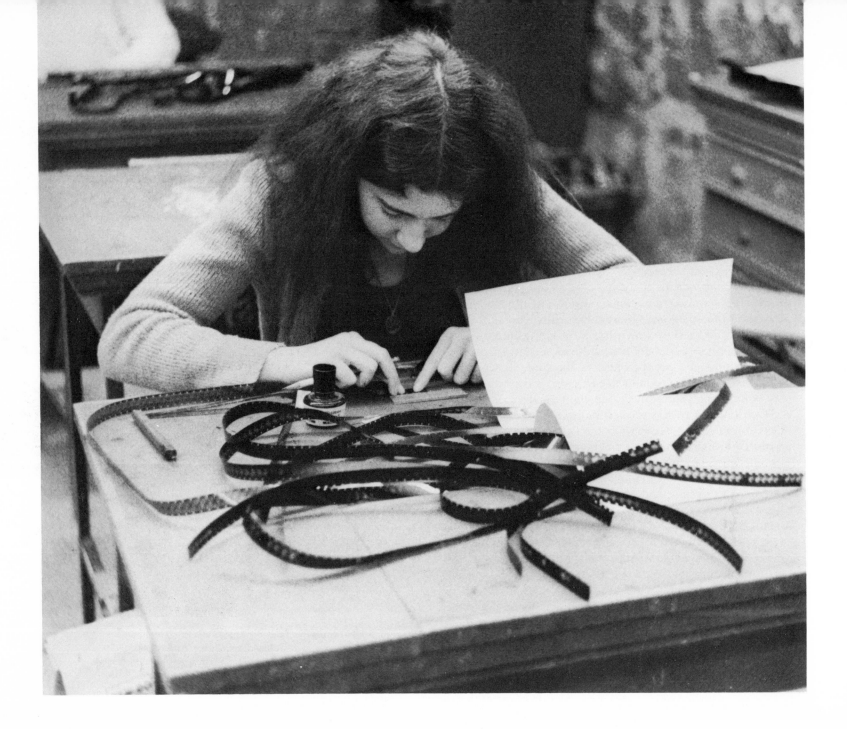

ning with photography, moving to the slide tape, and proceeding finally to film-making. In order to retain many of the light exercises of the original study, new applications for their utilization in the kinetic film had to be found.

LIGHT MODULATORS The beginning project examines the potential of light as an esthetic medium. The student learns that a beam of light can be blocked, divided into patterns, colored in flat or graduated areas, and subjected to all varieties of movement. The light modulator is an instrument capable of producing many of these effects. Although there are several types of modulator, the one that manipulates a beam of light most effectively is an open structure containing planes that will in some way alter the light beam. Motion of light is achieved by imparting movement to the modulator itself. Since making an open structure is a three-dimensional construction problem, the materials that are selected must produce the desired results. Cardboard, paper, balsa wood, theatrical gels, and acetates are all workable materials. Students with imagination can and will discover other suitable materials. One effective modulator was made from paper cups, for example. When completed the modulator is placed before the light beam of a projector and rotated to create moving patterns of color on either a conventional or a rear-projection screen. It may also be used in projects such as the light show or kinetic light film (to be described later).

CAMERALESS SLIDE-MAKING After experiencing the excitement of moving color and patterns produced by the light modulator, the student is introduced to another method of altering light—the cameraless slide. A beam of light can be transformed by introducing materials between the light source and projection lens. These materials can be opaque,

11–5. Editing "gets it all together," creating a rhythmic flow from scattered segments of film.

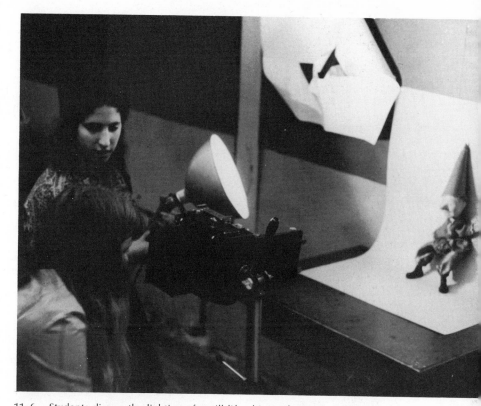

11–6. Students discuss the lighting of a still-life object. They do not linger over this stage and usually end up filming outdoors.

translucent, transparent, or in a combination of the three, but they must always be flat enough to produce a successful slide.

The slide project should be approached and executed as a purely creative and experimental activity, slide flatness being the only material limitation. To provide stimulation for students who are slow to become experimental, the teacher can introduce and demonstrate several slide-making methods such as stencil and etching as well as transparent color, transfer, polarized light, and other

techniques. This last allows the student to combine the various processes and to create new methods with new materials. Since many of these techniques have been the result of trial-and-error procedures in making slides, while others have resulted from using materials never designed for slide-making purposes, the alert teacher should be constantly scanning the market for new materials for possible use.

Making modulators and slides can be an end in itself, but if an application can be made to another project, both activities will have far greater utility. For example, slides may be used in conjunction with the modulators for a light show or both may be used to make a light film. The latter project gives the entire operation a degree of recorded permanence.

KINETIC LIGHT FILM When deciding upon some form of application for the completed slide and modulator projects, teachers and students have usually been in favor of the Kinetic light film. Material requirements for this activity are slide projectors, a rear-projection screen, and a motion-picture camera.

The students begin with a test session in which to experiment with their slides and modulators on the screen before any actual filming is done. During this trial-and-error period, notes are made concerning the effective use of the materials. After the rehearsal, the camera is placed in front of the screen with the slide projectors, modulators, and student performers behind it, and the light performance and filming are under way. First, sequences are filmed that use only the modulators; then slides are used; finally an orgiastic use is made of slides and modulators in combination. Much of what occurs on the screen is spontaneous, as there is no attempt during the rehearsal period to perfect a routine. After processing,

11–7. The super 8mm camera is used for film-making, both animated and live.

the film can be cut and edited, retaining only the effective sequences. When completed, the film offers an entirely visual experience; it does not require the inclusion of sound.

THE SLIDE TAPE Slide-making activities can also be directed to the slide tape, another visual-projection form that has been aptly called the poor man's film. Slide images are projected on the screen and mechanically changed by electronic signals on the sound tape, with sounds and images being synchronized as a unit to express the content of the presentation. A projector designed for this purpose, a tape recorder, and a synchronizer are the required instruments. If funds are available, it is possible to purchase a compact unit that contains the three basic components. The compact unit is, of course, simpler to use and eliminates the maze of wiring and electric plugs that might otherwise deter the nontechnical-minded teacher.

The use of the still camera as a slide-making tool in the slide-tape project further increases the student's knowledge of slide-making. The slide-tape project also introduces the basic problem of matching a visual image with a given sound. One exercise that achieves this objective is sound montage, in which a tape is made with an assortment of sounds arranged in a serialized or otherwise unified order. In this exercise a variety of sound is essential and should include both abstract and natural sounds. Radio, recordings, and television offer an endless source of sounds. The student's assignment is to create visuals for a portion of the sound tract, with the decision left to the student's personal interpretation of the sound whether to use cameraless or camera-produced slides. He may wish to consider printed material such as book or magazine reproductions or photographs for subject matter. Upon completion of the slides, selection of those to be synchronized to the tape may be made by a student panel.

FILM-MAKING: THE CAMERALESS FILM Conventional film-making is best preceded by the experience of making a cameraless film, by no means a new procedure. Many years ago the film maker Norman McLaren created a series of films by the application of color and design to film without the use of a camera. Although this method appears to be the natural first step to film-making, art departments have only recently begun to adopt it. Perhaps one reason for their reluctance to engage in this particular film-making activity in the past has been the laborious but necessary process of removing the emulsion from film in order to obtain a working surface. Now, however, film manufacturers are producing a clear film that obviates this process and an increasing number of suitable materials for use on the film are presently available. Interest in kinetic art has created a demand for art forms that best express abstract color and movement. The cameraless film is an excellent medium for obtaining these objectives and an invaluable experience for the beginning film maker.

Two methods can be used when working on clear leader film. The student may work from frame to frame, or he may choose to work on clusters of frames, depending upon his selection of animating tools and materials. If a pen and acetate ink are employed, the logical procedure is to move from frame to frame, but with a sponge dipped in colored inks or paint the student can create animated effects containing many frames, and, by reemploying the methods and techniques used in slide-making, the student can begin his cameraless film project. Experimentation and imaginative use of materials should be emphasized but always with an awareness of one limitation: the finished film must be flat enough to go through the machinery of a projector.

11–8. Using water color on Bristol board, a student prepares a background for an animated film. Animation may also involve people and objects, but the process remains the same.

Not only can the various directions of film movement be explored through this basic experience, but, after the completion of several feet of film and its projection on a screen, the student will understand what is meant by "film time" and the relationship of the frame to film time. Duration of movement on film can be expressed in words—"twenty-four frames per second"—but only by the actual experience of cameraless film-making can the meaning and importance of film time be fully realized.

FILM-MAKING: EDITING Of all the processes of the complicated art of film-making, perhaps the most attractive and challenging one to the artist is editing. The arranging and ordering of images to tell a story, express an emotion, or create an optical effect is directly related to all other visual-art forms. In the normal process of making a film, the student will inevitably gain an understanding of editing. Editing experience without the multitudinous problems connected with complete film-making can be provided for the student, however. And, by singling out the editing process for special study, this most important step in the making of a film is given necessary emphasis. Early in the 1920s, Russian film makers began to realize the importance of editing when their experiments with cutting and rearrangement of a completed film sometimes led to an improvement in the expressive quality of the film. To employ such a costly method for a group of students would be impractical. A parallel exercise quite within the means of the typical film class is that of providing each student with a supply of discarded film clippings, collected from a variety of possible sources and containing a maximum variety of subjects, action, and camera orientation. After the sequences are identified by subject, numbered, and listed and after all the footage has been scrutinized, the student may study the material for possible story or idea continuity. If the subjects do not lend themselves to this treatment, the student can always experiment for optical effects. The value of this project lies not only in the challenge to the imagination in handling film images but in the practice it offers in splicing film.

FILM-MAKING: THE STORY-BOARD Since film is a visual-art form, it seems appropriate to prepare for it by using pictures instead of words. This can be done by means of the story-board, a visual form of script-writing. Instead of describing each scene change with words, the scenario is presented with drawings on small cards that illustrate the changing scenes. The drawings need not necessarily be works of art. Film-making is basically a "picture" art and the story-board method of creating a visual shooting script not only aids the film maker in perceiving each scene but further emphasizes the relationship of each scene to the following one. After completion, the cards are mounted on a board in the order of continuity and can be studied for changes or additions.

The single most important aspect of this exercise is the emphasis placed on the shooting script. Most young people have an overly simplistic concept of film-making, viewing it only as a fun activity. Only when they discover that it entails more than merely looking into the camera finder and pressing the release do they begin to realize its complexity; when they are confronted with the series of preliminary problems inherent in film-making, they are often overwhelmed. Film-making requires the utmost in discipline and direction of purpose. Powers of visualization, imaginative resourcefulness, and patience are absolutely necessary to the making of a successful film. During this part of the course, the teacher will soon discover which individuals possess the patience and creative capacity for arranging the continuity of images for a definite objective, which are most apt at the intricacies of film-making.

After each student has prepared his solution to the assigned class project, all boards are discussed and one or more are selected for production. The class is then

divided up to perform the various functions of film-making. The creator of the selected story-board becomes the director, and he in turn assigns the other members to roles in the project—lighting directors, camera operators, actors, props handlers, and set makers. The student director is also to be responsible for the editing and the inclusion of sound in the final stages. The teacher assumes the role of advisor during the making of the film.

PHOTOGRAPHY The subject of photography in such an extensive light course must of necessity be limited to two basic operations—dark-room procedures and the operation of a still camera. All students during the course of study should experience both of these activities. The presence of photographic equipment and dark-room facilities will greatly influence their depth of understanding of the subject. Dark-room procedures can be introduced by two problems, the photogram and the magazine-page negative. The photogram emphasizes the importance of light control and composition with light-sensitive paper, while the magazine-page negative gives experience in contact printing. A studio exercise with still life, sculpture object, or portrait will provide an opportunity for use of the camera. With the development of a negative and the making of an enlarged print, the student will have covered the fundamentals of photography.

CONCLUDING PROJECT As a final assignment the student is given the opportunity to pursue in greater depth one of the introductory subjects—photography, film-making, or slide tape. Because of the usual limitation of materials, facilities, and equipment, it is desirable that all students not select the same project. Another way of solving materials and facilities problems is by independent study. Under this plan, the class does not meet as a group at a designated period each day. Instead, each individual stu-

dent determines the free time he has available for his project, and, after consultation with his instructor regarding the availability of equipment and facilities, he formulates his own work schedule. The independent study program exists in the structure of many schools today.

For students who elect photography, a portfolio of photographs covering certain esthetic and technical problems is the final objective. Inclusion of personal photographic interests in the portfolio can be made after the course assignments have been completed.

The film maker's attention can be directed to the completion of one of two types of film, either conventional or animated. Students who are art oriented are most often directed toward animated film. Animation procedures are usually simplified by working with movable materials. This activity can be carried out in the classroom. If the choice is conventional film, the student must be prepared to be cast adrift from the classroom, for such a project requires much outside attention and time. Both film forms require the inclusion of sound, a formidable problem in itself.

The final choice, slide tape, can be approached from two directions—from sound to visuals or from visuals to sound. The range of possible subjects in this medium is virtually unlimited, for printed images exist in bountiful supply. If the research required by this approach is not attractive, the student can create his own images by the direct use of the still camera.

To conclude, it should be reemphasized that the light course tries to give belated recognition to an arrangement of subjects and techniques that have existed in one form or another since the turn of the century. It makes no claim to originality except in its attempt to combine and show the relationship of the various light media in the context of public school instruction. Each year the course will be subject to additions and subtractions and, in the

11–9. A film can be made by animating simple objects.

effort to retain receptiveness to the essence of change, may never achieve a fixed structure. Finally, the art teacher should recognize his unique responsibility to the media. He must not be deterred by dying bulbs, blown fuses, and the intricacies of light machines. Students today have long been conditioned to the blinking of the television tube, the flicking of the film, and the dazzle of the light show. Poster paint, watercolors, charcoal, and other traditional media still have a lingering place in this transitional period, but light is the element of tomorrow.

11–10. A group of students creates a commercial. Students, normally critical of professional efforts, get a chance to exercise their own taste.

BIOGRAPHICAL NOTES

MARGARET BINGHAM began as a painter, studying at Briarcliff College and Columbia University. Her work as a public school teacher led her to an M.A. in art education from New York University. In 1966 she received a Ford Foundation grant to develop arts curricula for ghetto schools in Washington, D. C. During this period she also served as consultant to Inter-American University in Puerto Rico. She is presently working in the Philadelphia schools, developing the ideas described in her article.

DON L. BRIGHAM is art director for the Attleboro public schools in Massachusetts. Before that he was the recipient of a Fulbright scholarship to France and a museum director in Indiana. He has taught at the University of Colorado and the Pomfret Academy, Pomfret, Conn. He holds an A.B. from Clark University and an M.F.A. from the University of Colorado, and he has also studied at Yale University on a fellowship.

LOWRY BURGESS has taught art history at the Philadelphia College of Art and is presently director of the foundation of design course at the Massachusetts College of Art.

His work with young people includes teaching at private schools and being art supervisor of the Weston public schools in Massachusetts. He worked one year as artist in residence for the Newton public schools in Massachusetts and he recently contributed an ice work to the exhibit of concept art sponsored by the Museum of Fine Arts in Boston. He has designed games for the social studies unit of the Educational Development Corporation. He taught the "hidden landscape" course at the Goldsmith College of Education, University of London. He was encouraged by the late Sir Herbert Read to expand his ideas into book form and did so in *Fragments: A Way of Seeing, a Way of Seeking*, published by Workshop for Learning Things, 5 Bridge St., Watertown, Mass. 02172 (1970).

RITA DeLISI is a graduate of the College of Mt. St. Vincent and of Catholic University. She developed her ideas of teaching art as director of Project, Inc., in Cambridge, Massachusetts, after teaching in New York high schools and at Boston State College. She has lectured and conducted seminars at Harvard University, Webster College, Bank Street College of Education, Sarah Lawrence Col-

lege, and Bennington College. She is presently making and exhibiting jewelry. In preparing her article, she received editorial assistance from Nina Solomita, one of her former students.

ELLIOT W. EISNER, professor of education and art at Stanford University, works in both art education and general curriculum. He is co-editor of *Readings in Art Education* (1966), editor of *Confronting Curriculum Reform* (1970), and author of *Educating Artistic Vision* (1972). He has served as chairman of the research committee of the National Art Education Association and now serves on the board of editors of *Music Educators Journal* and *Art Education*, and he is a member of the editorial board of *Review of Educational Research*. In 1967 he was awarded the Palmer O. Johnson Memorial Award for research by the journal of the American Educational Research Association. In 1969 he received a John Simon Guggenheim fellowship to study schools in England and Israel. He is presently on leave, teaching at the University of London.

GUY HUBBARD, with a Ph.D. from Stanford University, is head of art education at Indiana University. His public school art-teaching experience includes suburban and small-town schools as well as inner-city assignments in England, Canada, and the United States. He has taught students ranging from the upper elementary grades to senior high school. He co-authored the Modern Art Series Portfolio (1962) and authored *Art in the High School* (1967). He has contributed to *Art Education, Studies in Art Education,* and other publications, and he is active in the National Art Education Association.

STANLEY MADEJA is director of the esthetic education program of CEMREL, Inc. He was formerly art education specialist in the arts and humanities program of the U. S. Office of Education. He directs the artist-in-residence program of CEMREL and the JDR 3rd Fund Project of University City, Missouri. He designs jewelry, has marketed a series of films, has written for *Art Education, School Arts, Studies in Art Education,* and has served as editor for *Journal of Aesthetic Education* and *Exemplary Programs in Art Education.* He holds a Ph.D. from the University of Minnesota.

MARY J. ROUSE was born in Louisiana, received a B.A. in art from Louisiana Polytechnic University, an M.A. in art from Louisiana State University, and a Ph.D. in art education from Stanford University. She has taught at Louisiana Tech University and at a high school in California and is now associate professor of art education at Indiana University. She has published research monographs and articles in professional journals and is now senior editor of *Studies in Art Education.*

LLOYD SCHULTZ is a graduate of Massachusetts College of Art and taught in several public schools before going to Newton, Massachusetts, as head of the art department at Newton High School. He holds an M.A. in art education from the Institute of Design in Chicago and has studied in Harvard University's department of design. He is also a painter and film maker and has contributed an article on light education for *Today's Art.*

DON SEIDEN, in addition to teaching art education at the Art Institute of Chicago, is chairman of the sculpture department there. He is also director of art therapy at St. Luke's Presbyterian Hospital and is on the planning committee for Metro High School for the board of education

in Chicago. In addition to exhibiting as a sculptor, he has written a book on that subject, *Direct Metal Sculpture* (1966), and he is a popular lecturer on TV for National Educational Television.

RONALD H. SILVERMAN received his B.A. from the University of California; his M.A. and Ph.D. from Stanford University. He was formerly president of the California Art Education Association and has taught in Canada and Great Britain. He is a member of the editorial board of *Studies in Art Education* and has written numerous articles deal-

ing with both crafts and art education. He is currently professor of art at California State College in Los Angeles.

JAN WAMPLER received his education at the Rhode Island School of Design and Harvard University Graduate School of Design. He has taught at the Boston Architectural Center, at the Inter-American University in Puerto Rico, and at Harvard University and is currently assistant professor of architecture at Massachusetts Institute of Technology. He was awarded the Progressive Architecture Annual Design Award and has designed schools, housing projects, day-care centers, and new towns.

A 2
B 3
C 4
D 5
E 6
F 7
G 8
H 9
I 0
J 1